Being Bold with Watercolour

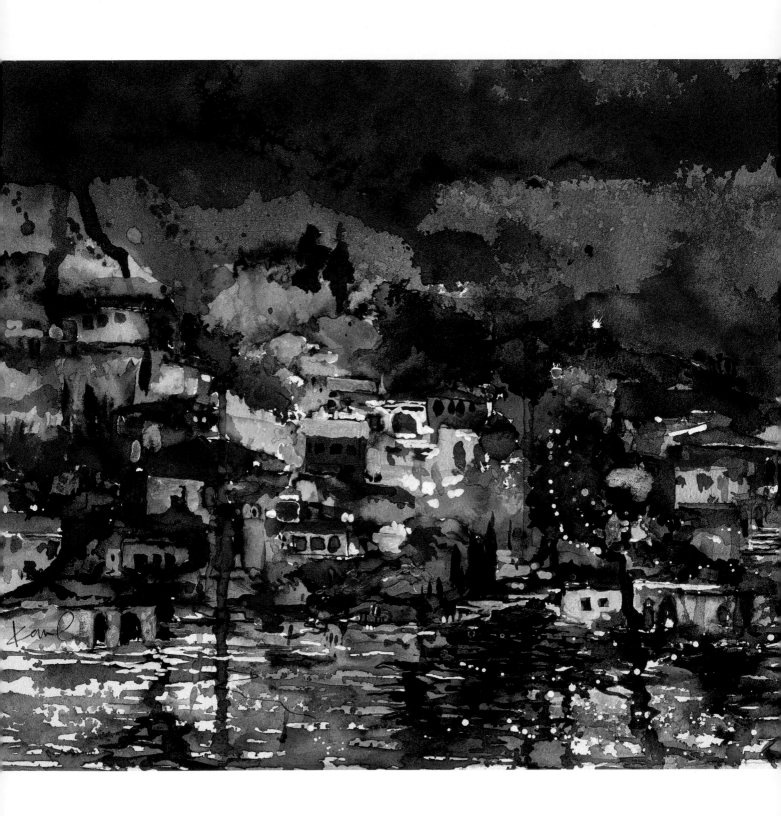

Being Bold with Watercolour

Annette Kane
with Robin Capon

BATSFORD

For my daughter, Eva

Acknowledgements

I was delighted when Robin Capon suggested that we produce a book together, and I would like to thank him for his skill and ability in organizing the various aspects of my working life into a coherent order. He has not only made the process relatively painless for me, but he has also helped me to contemplate my years as a watercolour painter and to organize my thoughts about the business of painting.

I have always had immeasurable support from my husband, Eddie, and for this I will always be grateful.

Thanks also to Gill Catto and Iain Barratt at the Catto Gallery, and Marie-Louise Woltering and everyone at the Clifton Gallery, for being such great people to work with over the years.

Annette Kane is mainly represented by the Catto Gallery, 100 Heath Street, London NW3 1DP. Tel: 020 7435 6660; www.catto.co.uk

First published in the United Kingdom in 2006.
This paperback edition first published in 2011 by
Batsford
10 Southcombe Street
London W14 0RA

An imprint of Anova Books Company Ltd

Copyright © Batsford
Text © Robin Capon
Illustrations © Annette Kane

The moral rights of the authors have
been asserted.

ISBN 9781849940108

A CIP catalogue record for this book is available
from the British Library.

10 9 8 7 6 5 4 3 2 1

Reproduction by Spectrum Colour, UK
Printed by Craft Print International Ltd, Singapore

This book can be ordered direct from the publisher
at the website: www.anovabooks.com, or try your
local bookshop

Distributed in the United States and Canada by
Sterling Publishing Co., 387 Park Avenue South,
New York, NY 10016, USA

Page 2: Broad Day
58.5 x 84 cm (23 x 33 in)

Contents

Introduction

Painting is something I greatly enjoy, and I am certainly fortunate to be able to earn my living in such a rewarding way. Having qualified with a degree in fine art, I have always worked in the broad field of art and design. But it was not until about fifteen years ago that I decided to devote all my time to painting. This was undoubtedly a good decision for me, although I would say that any success has resulted as much from my businesslike approach as from my ability as an artist. The art world is a very competitive place and to succeed I think you have to work just as efficiently and effectively as you would in any other job.

I am also lucky that my work seems to have a broad appeal. Most of my paintings are colourful and decorative, and many people find that such pictures have a feel-good factor and are easy to relate to. I accept that my work is not exceptionally innovative and that it is essentially illustrative. But it reflects my ideas and feelings, and I make no apology for painting in a style that is true to myself. In fact, this is something that I would encourage every painter to do. If you are not naturally experimental and freely expressive, why try to be!

As well as having an inherent integrity, I think each artist's work should show a degree of originality and express a different view of the world. It need not be radically different, but it should reveal something new and personal. I try to make my paintings slightly unusual in their design. For example, I like compositions in which the viewpoint is directly from above, or perhaps focused on something very close up. Also, since I started painting in watercolour, I have gradually introduced

Nineteen Years Later and a Different Figure
109 x 193 cm (43 x 76 in)
I particularly enjoy tackling subjects like this one, in which there is scope for interesting pattern and texture effects throughout the painting.

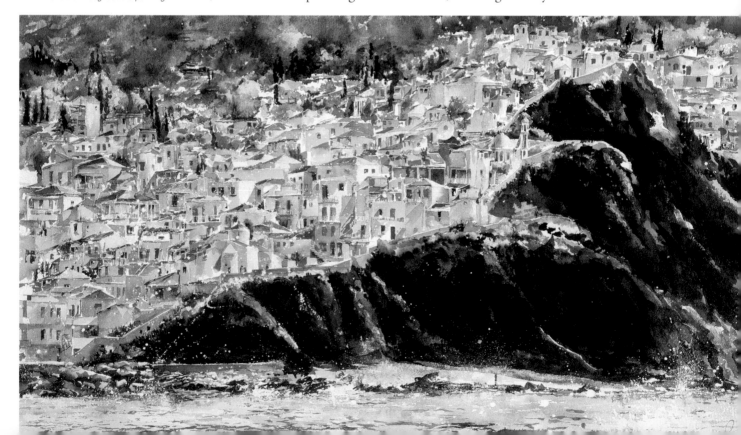

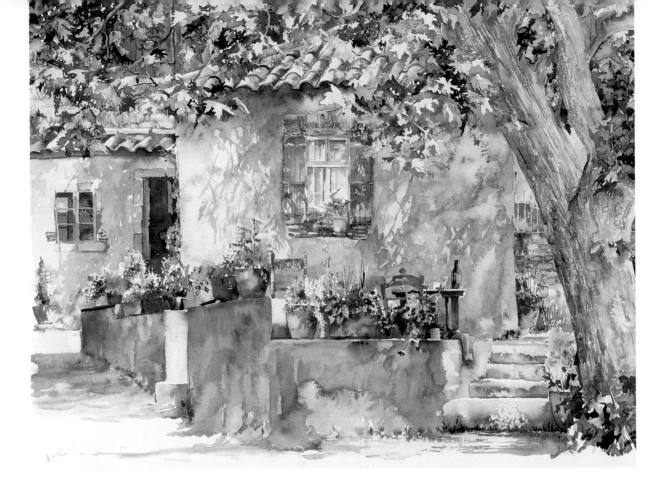

a wider range of painting techniques into my work. These, used
with care and discrimination, have added further variety and interest
to my paintings.

Watercolour is a delightful medium to use and it offers a great deal of
potential for all kinds of subject matter. However, it is what I would call
a technique-based medium. By this I mean that it is difficult to succeed
in watercolour without first learning the basic skills and methods of
handling the paint. Unlike oil paint, which is a very forgiving medium,
there is little scope to change your mind and rework areas in
watercolour. So to paint well it is essential to gain confidence by
acquiring the necessary skills and experience.

Of course, this is not to say that there is a set procedure for painting
in watercolour. Quite the contrary. Once you have some experience and
confidence there are lots of ways that techniques can be adapted to suit
your own aims and ideas. Watercolour is surprisingly versatile, and one
aspect that particularly interests me is the opportunity to use colour in
a bold, positive manner. In my view there is no reason why watercolour
should only be applied in weak washes, and similarly no reason why it
cannot be combined with other media and techniques, such as inks
and wax resist.

Painting is a magical business. What I find so fascinating is the way
that liquid colour can be turned into something recognizable, and
gradually shape an image that people can understand and hopefully
appreciate. It is also an absorbing, compelling business. There is always
something new to learn, always the excitement and satisfaction of being
able to create even better paintings. Indeed, like me, you will probably
find that the more you paint, the more you want to paint!

Sea Through
53 x 74 cm (21 x 29 in)
*Watercolours have a wonderfully fresh
and transparent quality, which can give
a convincing feeling of light and space.*

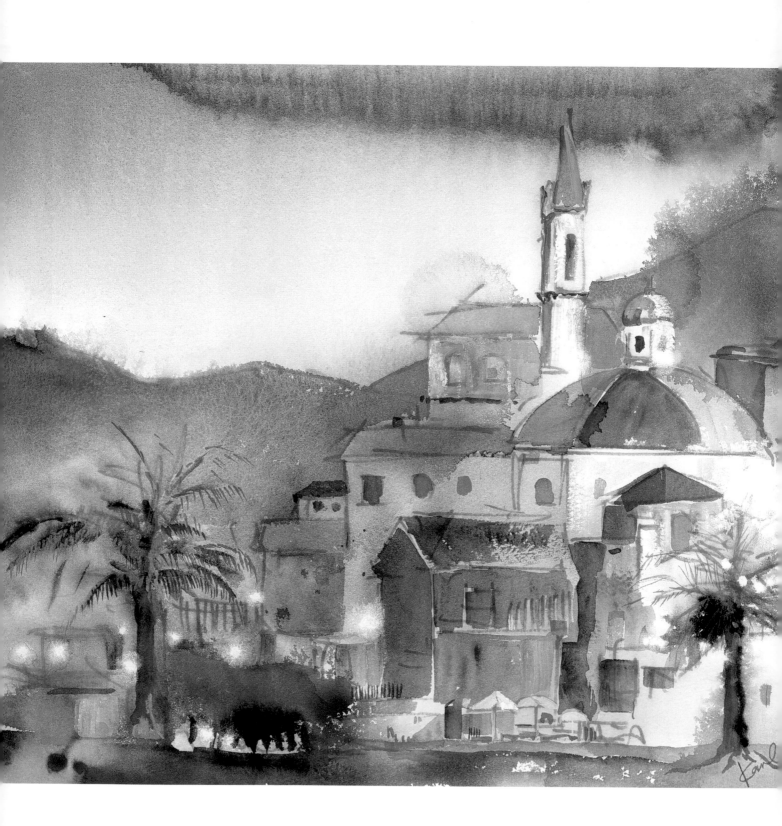

1 | Essential Skills

Most of us paint because we instinctively want to paint; it is the way that we can best express our thoughts and feelings about things. At the same time, we find painting enjoyable and fulfilling, which is an added attraction.

Equally true, however, is that although painting is often fun and certainly rewarding, it is seldom easy! There are lots of factors to consider when painting, many techniques and effects to master. Moreover, if we are to develop as artists we must be ambitious in our work, and willing to try new things, which inevitably means that not every painting will succeed as we had hoped – although of course we can learn as much from the disappointments as from the successes. The most important thing is to persevere. Yes, painting is a challenging business, but in my opinion there is nothing quite as satisfying as a finished painting in which I have managed to capture the sense of colour, mood and other qualities that first inspired the work.

Success in painting depends to a large extent on confidence. This is turn develops from acquiring skills and experience. To paint well requires an understanding of the medium – be it watercolour, acrylics, oils or whatever – and a knowledge of its strengths and limitations. Also, there is much to learn about colour, various paint-handling techniques, painting materials and equipment, and so on. These essential skills will provide a good basis to work from, but remember too that successful paintings are not only about applying paint in a competent way. Just as important is the ability to use such skills with a degree of individuality, so that you can convey what particularly impresses you about the subject matter you want to paint.

Understanding Watercolour

Each painting medium has its own qualities and potential. Oil paint, for example, is slow-drying and consequently allows plenty of time to try out different possibilities. In contrast, acrylics and watercolour dry much faster, which can also be an advantage, especially when painting

Early Evening, Italy
36 x 41 cm (14 x 16 in)
As here, I sometimes use felt tip pens for the initial drawing. When the watercolour washes are added, the pen lines blend in with the rest.

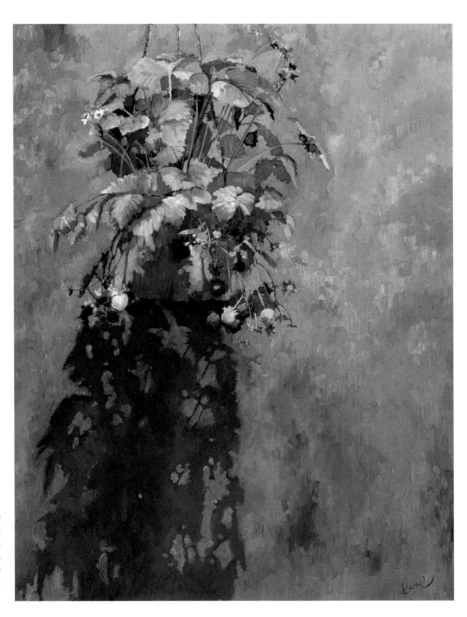

outdoors. Obviously the choice of medium will greatly influence the scope and character of the work and indeed play its part in determining the style of the artist. So, we need to find the medium that we feel most comfortable with; that allows us to work in an uninhibited way and tackle the sort of subjects and ideas that most appeal to us.

Despite its reputation as the least predictable and controllable of all the painting media, watercolour is extremely popular, particularly among those who are new to painting and are eager to see what they can achieve. In fact there are good reasons why watercolour is the best choice for anyone interested in learning to paint. It is a wonderfully fresh and direct medium to use and, being quick-drying, it enables you to work on a painting almost continuously until you have built up all the effects you

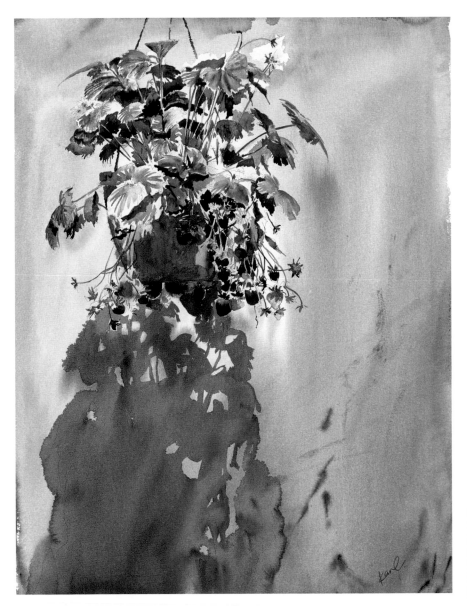

Strawberries *watercolour*
76 x 56 cm (30 x 22 in)
In contrast, the colours in a watercolour painting are lightened by adding more water, and for any pure white shapes the paper is left unpainted (assuming you are using white paper).

want. Watercolour requires little in the way of essential equipment and materials, and an additional advantage is that all the necessary items are lightweight, compact and easy to store.

Interestingly, it was the practical considerations that first attracted me to watercolour. Having finished my degree course (which incidentally was in sculpture rather than painting), I worked for several years as a graphic designer and then trained as a teacher. At that time I lived in a small flat in Leeds. There was very little space in which to paint, so I decided to try watercolour. Not only did it prove convenient, but I also found that it suited the way I wanted to paint. I soon discovered that I could develop colours and tones quickly and effectively, and for me there were some exciting new paint qualities to explore, such as fluidity and transparency.

Advantages and Potential

For many artists the appeal of watercolour lies in the way that it can be applied in subtle washes (a 'wash' is a thin layer of translucent watercolour paint) to capture the transient effects of light and mood. Consequently it is especially popular for landscape subjects, where its immediacy and translucency are ideal qualities for expressing the fleeting nature of the weather and the sense of atmosphere and place. There is a long tradition of watercolour landscape painting, particularly in Britain, and many of the techniques that we currently use have their origins in the work of past masters such as Thomas Girtin, JMW Turner and John Sell Cotman.

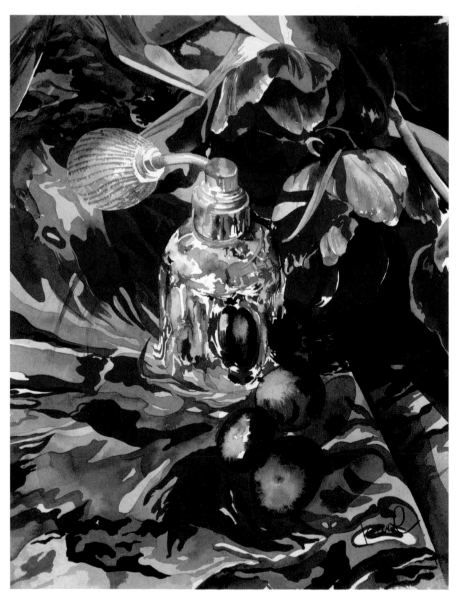

Perfume
28 x 20.5 cm (11 x 8 in)
Watercolour can also be applied quite thickly. I felt that this subject needed thick, bold colour to bring out its full impact.

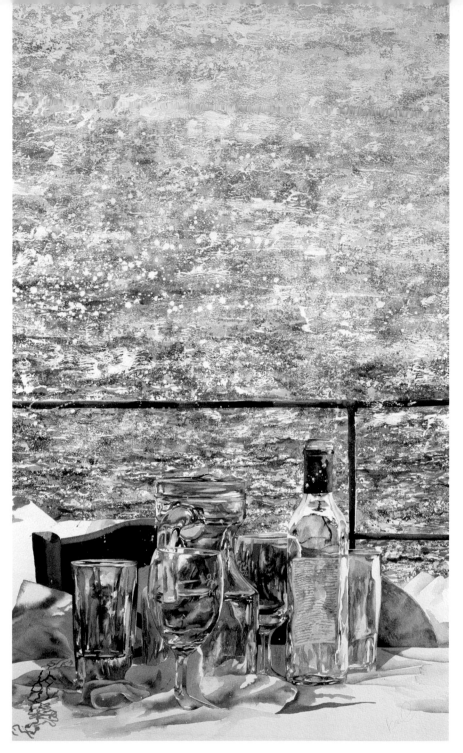

Drunk by the Sea
69 x 41 cm (27 x 16 in)
The transparent quality of watercolour makes it an ideal medium for painting subjects such as glass and water.

Essentially, the traditional approach for watercolour painting relies on reserving the whites (leaving unpainted paper to represent white areas), using a limited palette of colours, and building up the necessary strength of colour and tone (the brightness or darkness of a colour, varied by adjusting the proportion of water to paint) with a succession of weak washes. Many artists still prefer this method of working. Indeed, some are adamant that it is the only way to use watercolour. They argue that the true character of the medium lies in the subtlety, purity and transparency of the colours, and that on no account should these qualities be diminished by the introduction of any other kind of media or techniques.

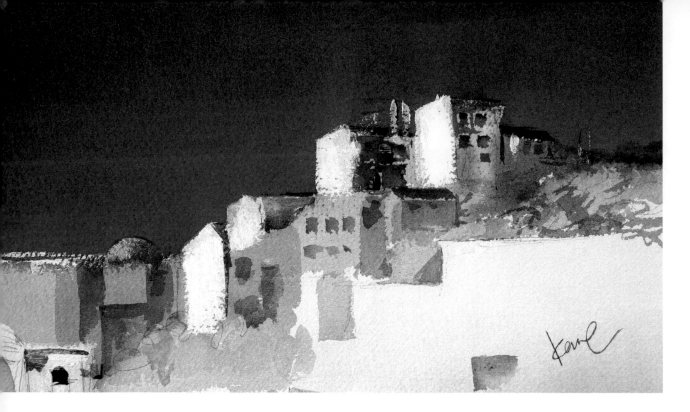

Greek Height
15 x 28 cm (6 x 11 in)
As with the blue in this painting, I am never afraid to exaggerate colours if this will give them more 'punch'.

However, while I respect that the disciplined, purist approach works well for some artists – and it certainly produces some very fine paintings – it is not for me. I do not hold with 'rules' in painting; I like to work with as much freedom as possible. Although, as I have mentioned, it is essential to understand the medium and appreciate what it can and cannot do, I like to experiment and explore as wide a range of techniques and effects as possible.

Watercolour is surprisingly versatile. It can be used thinly, thickly, loosely or in a more controlled, detailed way, as well as in combination with other media and by employing techniques that exploit the 'happy accidents'. For example in *Drunk by the Sea* (page 13) I have made use of the transparent quality of the paint to convey the effects of water and glass, whereas in *Perfume* (page 12) the paint has been applied thickly and the colours are rich and strong. And, having started in watercolour, I often work over some areas with other media. In *Greek Height* (above) I have used white acrylic as well as watercolour, and in *Villa, Como* (right), one of my smaller, more experimental paintings, I have tried a variety of effects, including dribbles, splashes, white ink, and pen and ink.

Individual Expression

It is true that some watercolour techniques can be unpredictable, but this is part of the charm and challenge of working with the medium. When applying a broad wash of colour, for example, you never know exactly how it will settle and dry on the paper. Similarly, with techniques such as spattering or wax resist, there is always an element of chance and surprise. With experience, you learn how to exploit these characteristics and turn them to your advantage.

Because of the versatile nature of watercolour it is an excellent medium for developing your own means of expression, your own

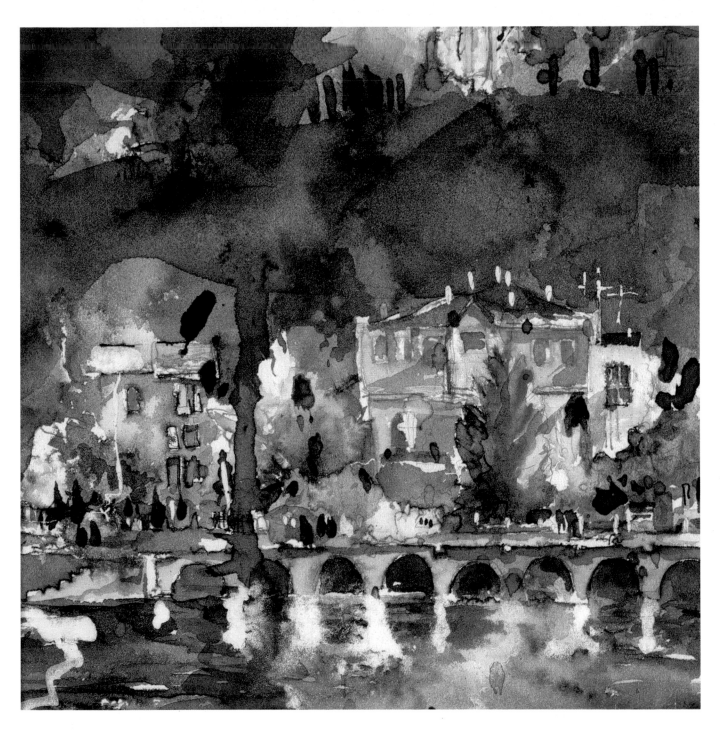

Villa, Como
18 x 18 cm (7 x 7 in)
Sometimes it is good to work in a much freer way. I have incorporated a variety of effects here, including wet-into-wet, dribbles, splashes and white ink.

Aspects of an English Summer
63.5 x 96.5 cm (25 x 38 in)
Another different approach – here exploiting the potential of the medium to show tremendous detail.

personal style. There is immense freedom either to work with precision and control or to try a spontaneous, experimental approach. Or, like me, you could vary your technique to suit your mood and the idea you have in mind. Another advantage is that it can be used for a wide range of subject matter – not just landscapes, but still lifes, people, interiors, buildings and so on. And do not believe those who say that watercolour is not the medium for strong colour. For me, colour is always one of the most powerful elements of a painting and I have never found it difficult with watercolour to achieve the richness and impact of colour that I wanted. *Broad Day* (below), for example, demonstrates how a watercolour can be just as powerful and imaginative in its use of colour as any other type of painting.

Broad Day
58.5 x 84 cm (23 x 33 in)
Certainly for me, watercolour can be just as colourful and expressive as any other medium.

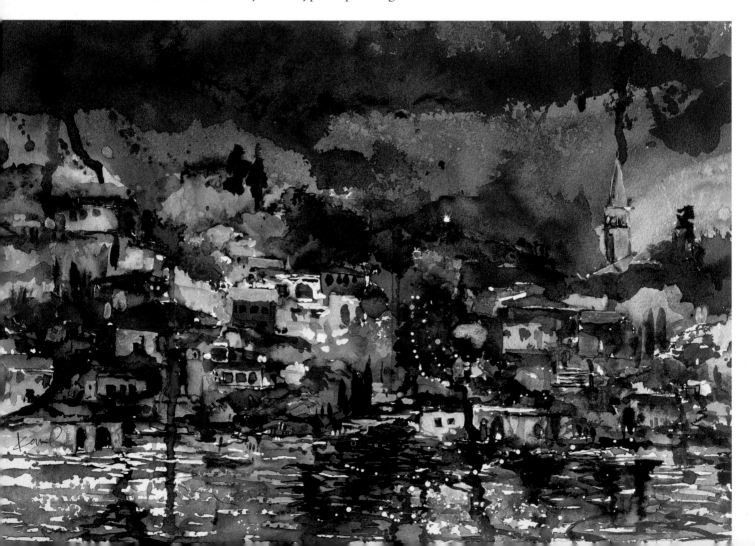

Choosing the Right Equipment

Unlike when working in oils and most other media, only a small amount of preparation is required for watercolour painting. In fact, if you choose to paint on heavy-quality paper or on a watercolour block (a pad of paper gummed on all four edges) and so avoid the necessity of first 'stretching' your paper, then no preparation is needed at all. This, coupled with the fact that you need only a few items of equipment to get started, makes watercolour the perfect medium for painting in any location – indoors or out. Essentially, all you require is a sheet of paper, a small paintbox, one or two brushes and some water.

I now buy certain papers that I know will help me create the effects I want. Gradually, I have also found the best colours to use and some versatile, hard-wearing types of brushes. These three items – paper, paints and brushes – are each influential in determining the sort of work that is possible. It takes time and experience to find the most suitable materials, and a good deal of experimentation. So, my advice is to not simply keep to one type of paper, paints or brushes. Introduce a different one now and again to see if this can help your style of painting.

Grand Abandoned Plans
61 x 89 cm (24 x 35 in)
I find watercolour perfect for detailed studies such as this, in which, incidentally, I have invented quite a lot of the colour.

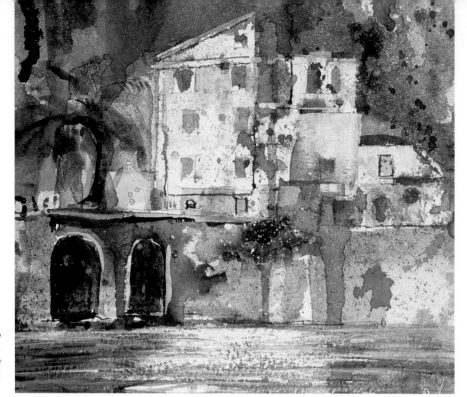

Amalfi II
17 x 15 cm (6½ x 6 in)
Just a small, quick watercolour study of some buildings that I thought had a special kind of charm and intimacy.

Rocky Reflection
66 x 46 cm (26 x 18 in)
For my controlled approach and subjects that require a lot of detail, I choose a Not-surface paper.

Paper

My preference is a heavy-quality paper with either a Not or a Rough surface, such as 640 gsm (300 lb) Saunders Waterford or Arches Aquarelle. I buy standard and sometimes very large sheets – around 102 x 152 cm (40 x 60 in). I also use 535 gsm (250 lb) Bockingford Not for quick experimental or sketchy paintings and occasionally for more resolved pieces if there is no Saunders or Arches available. Generally I choose the Rough surface paper for my more spontaneous, expressive paintings and for those in which texture is important. The Not surface is much better for detailed work such as you can see in *Rocky Reflections* (bottom left).

I have tried many different papers and surfaces in the past, including card and watercolour blocks. In my experience, Bockingford is one of the best general-purpose papers to use when gaining confidence with some of the basic watercolour techniques. You could start with a medium-weight type, for example 300 gsm (140 lb) Bockingford, but this will need stretching (see page 20 for how to do this). Later, as I have suggested, it is worth experimenting with other papers of different weights, textures and colours. I have never worked on tinted papers, but some artists find them perfect for creating atmospheric effects, choosing a tint that will enhance the colour, mood and other special qualities inherent in the subject. Tinted papers include Bockingford (available in blue, eggshell, grey, cream and oatmeal colours) and the 'De Nimes' range manufactured by Two Rivers (available in green, cream, sand, oatmeal and grey).

A Change in the Wind
30 x 30 cm (12 x 12 in)
Not-surface paper is also a good choice when you want the paint to puddle and bleed.

Heavy-quality papers will take a lot of wash, brush work and paint effects without any damage to the surface, and another reason why I choose them is that they do not need stretching. However, you may prefer to work on a 425 gsm (200 lb) paper or less, in which case it is advisable to stretch the paper before you begin painting. This is because thinner papers are prone to buckle and distort when the watercolour washes are applied.

The procedure for stretching paper is essentially as follows: soak the sheet in a tray or bath of clean water for a minute or two; place it on a drawing board or similar thick board and sponge off the surplus water; fix the sheet in place by using a strip of 5 cm (2 in) gummed brown paper tape along each side; and finally leave it flat to dry at room temperature. Like most artists, with experience you will find a way of adapting this basic technique to suit the particular papers and working methods you like to use.

Paints

Watercolour paints are available in tubes and also pans, which are small blocks of compacted, dry colour that are either square (half pans) or oblong (whole pans). Pan colours are fine for outdoor sketching and for any type of work involving small quantities of colour, whereas tube colours are more suitable for a freer approach and mixing large amounts of colour wash.

Tube paints have a moist, reasonably fluid consistency, and in my opinion they are a better choice for keeping the colours pure and fresh. Pan colours must be used with some care, otherwise the surface can become muddy through contamination with the surrounding colours. But if you like working from a paintbox, my advice is to start with pan colours, and when they are used up, refill the pans from tube colours.

Below: My palette in use, and the surrounding work area.

Below right: My palette. I set out the colours in this way, leaving spaces for mixing.

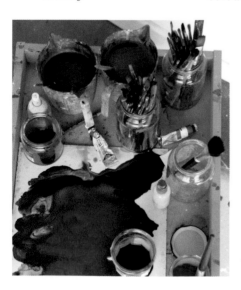

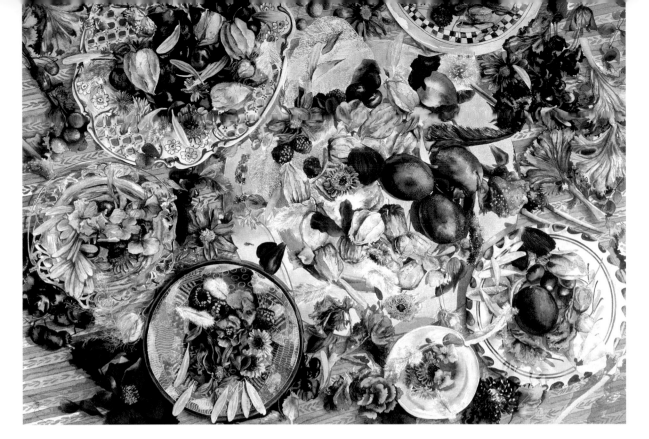

Because pure, vibrant colour is important in my work, I only use tube colours. I put out a fresh selection of colours every day. My palette is a flat piece of 20 x 30 cm (8 x 12 in) white, matt Formica (see the photograhs, opposite) and on this I place whatever colours I need for a particular painting, leaving a space next to each colour as a mixing area. The advantage of the Formica palette is that it is easy to clean and does not absorb any paint. In the past I have also used bits of scrap paper and card as disposable palettes.

You do not need a huge array of colours to begin with, although like me you will probably start to accumulate a wider range of specific colours as you discover which ones suit the things you like to paint and the colour effects you want to achieve. A palette of two reds (cadmium red and alizarin crimson), two blues (ultramarine and cobalt blue) and two yellows (cadmium yellow and yellow ochre), plus perhaps a couple of earth colours (burnt sienna and raw umber), is a good starting point.

Although all watercolours share certain characteristics, there can be subtle differences in the degree of transparency, staining power and other qualities from one colour to the next. For example, alizarin crimson, burnt sienna and Indian yellow are reliably transparent colours, whereas cadmium red, yellow ochre and green oxide are fairly opaque. Additionally, some colours, such as cadmium yellow and permanent mauve, are strong, staining colours, while others, including cerulean blue and raw sienna, have a tendency to granulate (produce an interesting textured effect).

As you get to know the different colours you can begin to exploit their individual characteristics to create particular effects in your paintings. Also, it is worth referring to manufacturers' charts to check the permanency rating, transparency and other qualities of colours that you want to use.

Petals, Plates, Plums
56 x 76 cm (22 x 30 in)
Colour is tremendously important in my work and I have spent a great deal of time experimenting with colours from different manufacturers in order to find the best selection to use.

Most of my paints come from the Winsor & Newton Artists' Water Colour range. However, over the years I have also experimented with colours from other manufacturers and have discovered several that I especially like, including Schmincke translucent orange and Old Holland blue-violet. In all, I have about thirty colours available in my studio, and from these I choose the ones that are appropriate for each painting – normally about ten or twelve. My basic palette includes lemon yellow, Indian yellow, scarlet or a dark orange, permanent or opera rose, crimson, manganese blue or a light turquoise, Winsor blue (green shade) or a deep turquoise, ultramarine blue, and burnt sienna.

Brushes

Here again, when you first start painting in watercolour it is advisable to keep things simple and so restrict yourself to perhaps three or four different brushes. In time you can add to these if you think there is a need for more choice in order to create a greater range of effects. For a basic selection I would recommend a large mop or a no. 12 round for general work and applying controlled washes; a 13 mm (½ in) flat brush for blocking in large areas of colour; and a no. 4 round for details.

The right type of brush makes it far easier to produce the particular texture, mark or wash effect you have in mind. I now have a good selection of mops, rounds and flats in different sizes, and also various other brushes for special effects. Sable hair brushes are often recommended for watercolour painting, but in my view the quality of sable can be inconsistent – and, of course, these brushes are expensive. Instead, I buy brushes in the Pro Arte Connoisseur and Prolene ranges, which are made with a mixture of sable and synthetic hairs. These have all the virtues of sable in their flexibility, pointing and paint-holding qualities, and they are reliable and hard-wearing.

As well as the various brushes I have mentioned, there are Chinese brushes, fans, hakes (wide wash brushes), designers' brushes (for details) and so on. Most art shops stock a wide choice, so look for the brushes

Below: This swordliner is one of the more unusual brushes I use. It will give delicate marks and thin lines as well as broad strokes.

Below right: Here is another unconventional watercolour brush – a filbert shape, which is useful for adding leaves and similar marks.

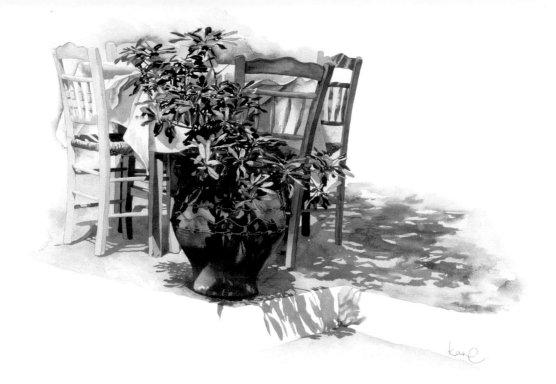

that will best suit the way you like to work. And having invested in some good brushes, do remember to look after them. Always rinse your brushes thoroughly after use in plenty of clean water, and then reshape the tips using your thumb and forefinger or a soft rag. Never leave brushes standing in water for hours at a time, as this will damage the hairs. When not in use, store your brushes flat in a tray or drawer, or place them upright in a jar, handles pointing down and hairs up.

Work Space

The main considerations are lighting and a table at which to work. Some artists prefer to paint only in daylight conditions, rather than by artificial light. However, this often creates time constraints, as good-quality natural light is difficult to achieve indoors for any lengthy period, especially in the winter months. Other artists opt for daylight-simulation fluorescent tubes and spotlights, which, unlike most forms of artificial lighting, produce the full frequency range of sunlight, making it possible to judge colours accurately. Whatever form of lighting you choose, ideally it should be of a consistent quality throughout the duration of your work on a given painting, to ensure consistency of colour treatment.

 I like to sit down when I am tackling a detailed painting, as this gives greater control. In contrast, I stand up for the more expressive watercolours, because here I want the freedom to manipulate the brushes and paint handling. I work at a large, tilting drawing board, increasing the angle when I want to encourage the paint to run, or adjusting the board to only a slight tilt for a more controlled approach. Of course, an adjustable drawing board is not a necessity. Instead, use a book to prop up your board, and swap this for a thicker book if you want to increase the angle. For painting outside, choose a lightweight adjustable sketching easel, making sure it is designed for watercolour painting and will hold the work in an almost horizontal position.

Other Useful Equipment

It is a good idea to have two pots of water available – one in which to rinse brushes and the other full of clean water for mixing colours. This helps to keep the colour mixes fresh and translucent. I use two plastic jugs for this purpose. I also use two plastic spray bottles for wetting areas of the paper, either before or after applying the colour washes: a small one (the sort that you buy in chemists when you go on holiday); and a larger one (in fact an empty window cleaner spray).

Most watercolour paintboxes incorporate some mixing wells, but these are usually inadequate. If you are working from a paintbox, my advice is to also buy a large plastic palette, which will give you more scope for colour mixing. Another advantage of a large palette is that the mixes are less likely to get contaminated by the surrounding colours. Most art shops have a good selection of watercolour palettes. In addition to the various items already mentioned, such as a drawing board, gummed brown tape and so on, other useful equipment includes a sketchbook and sketching materials and possibly masking fluid (a rubber solution that can be removed after painting to expose the unpainted paper beneath), some white gouache and sponges, tissues, cling film (plastic food wrap), salt and similar materials for different texture effects, as described on pages 34 to 36.

Confident Brushwork

Acquiring skills in watercolour painting depends to a large extent on the willingness to try things out and make full use of the medium's potential. In turn, of course, the confidence to do this comes from success, so it is a matter of starting with the basic skills and gradually developing your knowledge and understanding of watercolour by being continually enquiring and ambitious in your approach.

It is well known that watercolour can be unpredictable, particularly when used for freely expressed paintings. With experience, you learn to turn this unpredictability to your advantage by incorporating any backruns or other 'happy accidents' into the design and effects that you are aiming for. Again, this requires a certain confidence in handling the medium, as well as the ability to remain undeterred when things do not go exactly as expected.

Exploring Different Techniques

The versatile nature of watercolour, combined with the way that certain papers and brushes can be used to enhance particular effects, means that a wide variety of techniques is possible. In principle, the more techniques you are familiar with and the greater your experience at using

them, the better equipped you will be to handle different painting ideas and situations successfully. However, it naturally takes time to build up confidence with the full range of techniques. So the best approach is to start with the essential ones, such as mixing and applying the various types of wash, and then gradually increase and refine your skills.

For a number of years I concentrated on fairly controlled and detailed watercolours before I began to experiment and develop an alternative, looser approach. Similarly, whenever I have not painted for a while and I need to re-establish my confidence, I always begin with some quite careful, detailed paintings. This is a good way to start. I think it is difficult to work successfully in a truly expressionist, spontaneous manner until you have mastered all the basic techniques and the various associated aspects, including fundamental drawing skills, colour theory, perspective and composition.

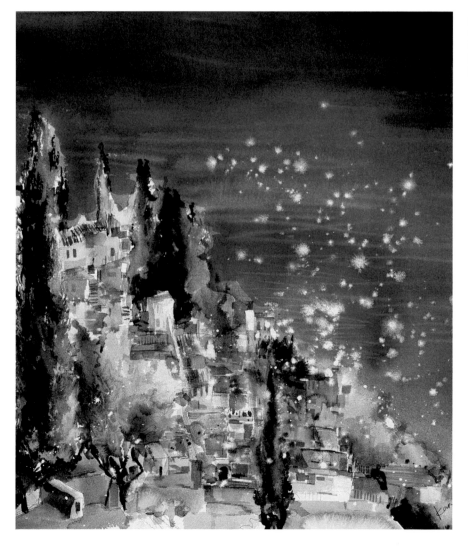

Amalfi Coast I
48 x 43 cm (19 x 17 in)
Generally, most of my colour washes are freely applied, using quite thick paint.

Now, with the ability to work in a number of different ways, I like to paint according to how I feel. I might choose to focus on some really experimental painting one day and on the next, in contrast, tackle something very complex from direct observation. But whatever I choose to paint and no matter what techniques I decide to use, I am always looking for a challenge. I avoid sticking only to the subjects and methods that I know will succeed. I believe the only way to progress in painting is to be adventurous and willing to explore a variety of ideas and approaches.

Washes

For wash techniques the paint must be well-diluted, and this is achieved by mixing a small amount of pigment (paint colour) with plenty of clean water. The wash is the principal technique in traditional watercolours, where, working from the palest areas, superimposed tints of colour are used to gradually build up stronger and darker tones. Washes are ideal for large background areas, but they can also be used in a more limited and controlled way.

There are three main types of wash: a flat, even wash; a graduated wash, which is often used for skies, where the colour gradually changes from light to dark as you move up or down the paper; and a variegated wash, where several colours are allowed to run together, either in a random or a deliberate way. For each of these you can work on either dry paper or, for a more diffused effect, damp paper. For a textural, broken colour quality, choose a heavy Rough-surface paper or use a colour that will granulate.

My liking for strong colour means that I seldom rely on the conventional wash technique. Mostly I apply colour in a very direct manner, aiming straight away for the consistency and strength that I want in the finished painting, rather than building it up in layers. I rely mainly on marks, lines and small patches of colour. When I do use a general wash, as in *Amalfi Coast I* (page 25), you will notice that the paint is quite thick.

Wet-into-Wet and Wet-against-Wet

Wet-into-wet is an established technique in watercolour painting for creating atmospheric, loosely handled and soft, blended effects. Consequently it is often used for interpreting the transient nature of skies and water as well as for other types of subject matter where subtle, diffused colour is a key characteristic. With wet-into-wet, colour is applied to damp or wet paper, or into or against other colours while they are still wet. This makes an exciting fusion of colour and, in contrast to the flat, direct wash, where the edges are clearly defined, a feature of wet-into-wet is that it creates very soft edges.

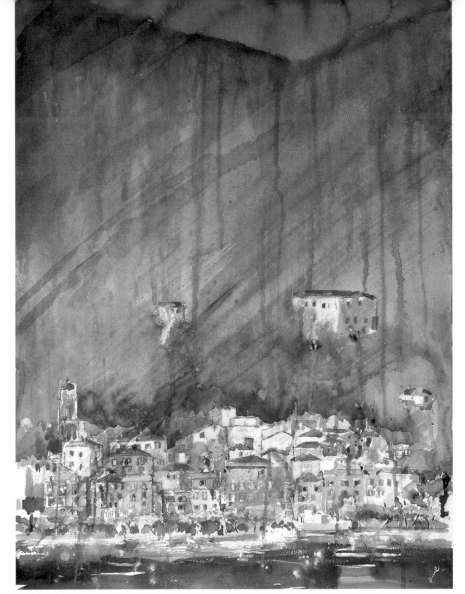

Como
76 x 56 cm (30 x 22 in)
I like the accidental effects that sometimes happen when using wet-into-wet or wet-against-wet washes.

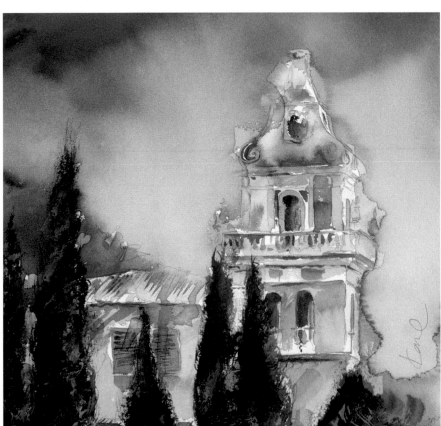

Towers of Turquoise
25.5 x 25.5 cm (10 x 10 in)
Working on damp paper, the colours fuse together and create exciting atmospheric effects.

Essential Skills 27

When painting wet-into-wet, timing is a crucial factor. Having wetted the surface of the paper, you must then judge how long to leave it before adding the colours. If some colour is added straight away, then the result will be a weak, very diffused effect. On the other hand, if you leave it too long, the colour will be broken and patchy, so you will usually want to aim for a happy medium. Another important factor affecting the timing, as always, is the choice of paper. Absorbent papers soak up the paint quickly, while those that are heavily sized (stiffened during manufacture by treating with a gel solution) will let the colour sit on the surface longer, allowing more time to manipulate the washes.

So the knack of painting wet-into-wet is in judging the timing of the washes, using an appropriate type of paper, and tilting the board to encourage (or prevent) the flow of paint to create the effect you want. I have used quite a lot of wet-into-wet washes in *Como* (page 27), for example, particularly in the background areas, and similarly in *Towers of Turquoise* (page 27). I often dampen the paper by spraying it with clean water, using a spray bottle as described on page 35. I also use the spray technique for wetting areas of colour when they are nearly dry, just to soften the effect a little.

A related technique is called painting wet-against-wet. This involves placing one brushstroke or area of colour against another colour that is still wet, so that the edges blend together.

Wet-on-Dry

As the name implies, wet-on-dry involves working with fresh colour over existing passages of dry paint or directly onto dry paper. This is the principal technique that I use for my more detailed, controlled paintings, as for example in *Andalusian Patterns* (right), since it allows you to paint shapes with distinct edges. I build up the definition and textures with a sequence of individual brushstrokes applied directly to dry paper, usually without any preliminary washes. This approach, and the use of an appropriately fine-haired brush, allows me to work with a good degree of control and on small areas at a time.

This technique works best on surface-sized papers, such as Arches Aquarelle. These papers hold the paint well and help ensure that the brushstrokes are kept in control. I use paint of a reasonably thick consistency, work with a variety of brushmarks and, as much as possible, rely on a single application of colour. I try to get the intensity of colour and the correct tonal value straight away, rather than developing these with a sequence of superimposed brushstrokes. This is because I want the result to look fresh and vibrant, and when colours are applied one over another there is an increasing risk of darker, muddy-looking colours.

Another consideration, especially when using thicker paint, is that the underlying colour has a tendency to 'lift' (pull away from the surface) and mix with any colours that are worked over it. However, I do

Andalusian Patterns
76 x 56 cm (30 x 22 in)
For a really controlled effect I work on small areas at a time, applying the colours to dry paper.

occasionally add a second layer of colour, particularly when I want to suggest a slightly broken colour effect or a deep shadow. Moreover, wet-on-dry can be just as successful when applied using conventional washes to build up colour values, rather than individual brushstrokes. If this is your preference, then my advice is to use no more than four superimposed washes, otherwise the colours can become muddy. Also, it is a good idea to test the sequence of colour layering on a scrap piece of paper before trying it out in the actual painting. Equally, take care to use a clean brush for each new colour, and check that the water jar is always full of clean water.

Whites and Body Colour

There are various ways to create whites and highlights in a watercolour painting. These include leaving appropriate areas of the paper unpainted (assuming the paper is white); using masking fluid; wetting and lifting out colour; scratching through the surface colour with a sharp knife or

Young Brother
43 x 43 cm (17 x 17 in)
Masking fluid can be applied with a pen or brush for details and highlights, or sprayed or flicked on to create a more random effect, as here.

point; and using white paint or ink. As shown in *Young Brother* (left), I occasionally use masking fluid, which can be flicked and sprayed on, while I sometimes add white details and textures with Chinese white watercolour or white drawing ink, as in the foreground of *Final Shore* (above). But most of the time I rely on leaving patches of white paper to suggest highlights and other white areas which, as in *Green and Upside Down* (below), can be softened, slightly tinted or blended into the surrounding colours if required.

Final Shore
48 x 76 cm (19 x 30 in)
The white patches in the foreground of this painting were added with some Chinese white watercolour and white ink.

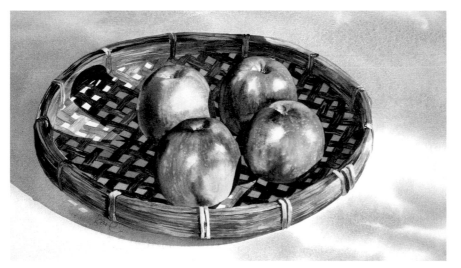

Green and Upside Down
30 x 45.5 cm (12 x 18 in)
For the highlights on these apples I have used the 'reserved whites' technique.

Reserved Whites

In paintings where the intention is to 'reserve' whites – that is, to leave them as areas of white paper – the work must be carefully planned from the outset so that any white areas are specified as part of the initial design or drawing. In a complex watercolour it may be necessary to indicate the white shapes in some way, so that they are not accidentally painted over.

Masking Fluid

Masking fluid is a rubber compound solution that is painted on to particular areas to prevent them accepting any washes of colour. It can also be stippled, spattered or sprayed on to a painting to help create textures and speckled highlight effects. You can use it at the start of a painting to reserve the whites, or at any later stage during the painting process to preserve certain effects.

Apply the masking fluid carefully, using an old, soft-haired brush or a dip pen. Use it sparingly, as it can damage the paper. Once it is in place you can paint right across the area, assured that the masked out shape will remain unaffected. The advantages of using masking fluid are that you do not have to remember where to leave a white gap, and that washes can be applied more quickly, as there is no need to paint carefully around the reserved shape. At the end of the painting you simply rub off the masking fluid to reveal the well-preserved shape underneath. If the outline is too clearly defined, you can use a water spray to wet the paper and blend in some of the surrounding colour to create a less obvious boundary.

Lifting Out

Although not a technique that I use, this can be helpful when you want to add a subtle highlight to an area that has already been painted. First, wet the area with a small stiff-haired brush and some clean water, slightly working the water into the surface of the paper but being careful not to damage it. Then, use a dry brush or some tissue paper to soak up the disrupted paint. Usually it is impossible to remove all the colour from the paper, and therefore the white that is revealed is subdued rather than brilliant.

An alternative method is to scratch out small marks and broken white areas from the dried paint surface with a sharp knife. This works best if both the paint and the paper are quite thick.

Body Colour

Body colour is opaque watercolour, and for whites and highlights this normally means using either Chinese white watercolour or, for greater covering power and intensity, white gouache. As well, some artists use white acrylic paint, and I often use white ink for adding highlights, textures, accents and details that need to be white.

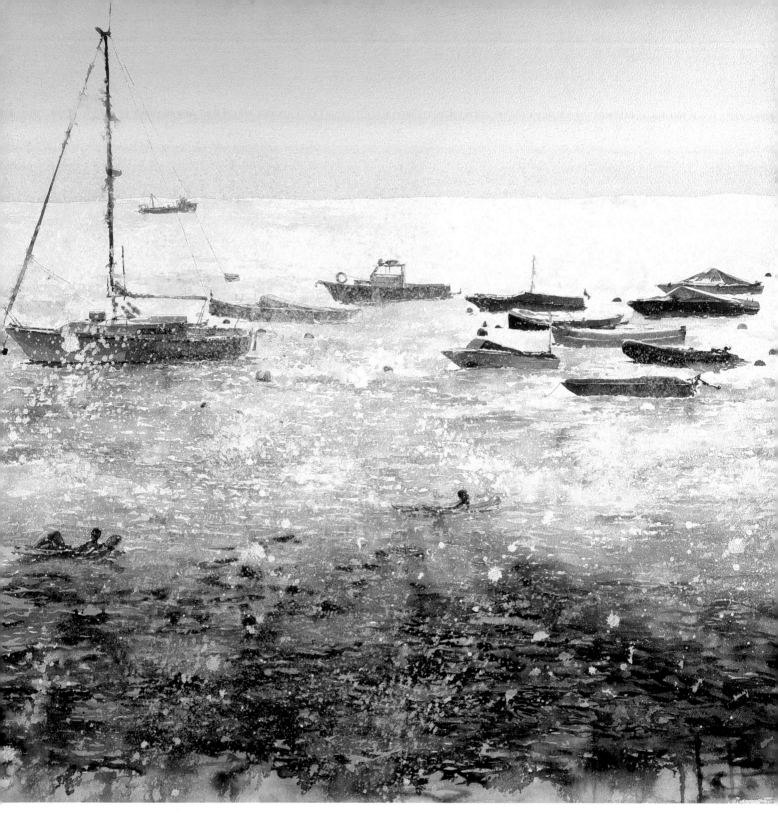

Boats, Boys, Buoys
53 x 56 cm (21 x 22 in)
There are various ways of suggesting texture in a watercolour painting, including the use of specific types of brushwork, and flicking and spattering techniques, as here.

Essential Skills 33

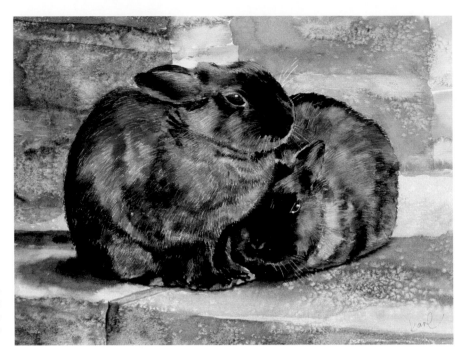

However, while this technique has its place, it should be used sparingly. I never mix white paint with other colours, as this produces an unpleasant creamy consistency and, of course, an opaque colour. Body colour whites can be subdued by working a thin glaze of colour over them, and similarly the edges can be softened and blended into the surrounding colours.

Texture Techniques

As I have said, watercolour is a surprisingly versatile medium and, although we normally think of it in terms of thin, transparent washes of colour, there is no reason why it cannot be used in a more painterly way, or with other media and techniques that help create a more prominent texture. For example, in many of my paintings I use salt, wax resist, spattering, spray and so on, where these techniques are appropriate for interpreting particular textural qualities. And sometimes the brushwork itself can suggest a certain texture, as in *Boats, Boys, Buoys* (page 33). Additionally, texture adds contrasting areas of interest in a painting, although as with any technique, it should not be overdone.

Salt
This is a good technique for suggesting textured walls, as in *Urban Bunnies* (above), and similar surfaces that have a soft, speckled appearance. You can use fine table salt or sea salt. Sprinkle it over the wet paint and leave to dry. Then brush off the salt.

Cling film
Use this technique to create a random, broken colour effect across a fairly large area. The method is straightforward and should give some

Left: You can make interesting broken colour effects by pressing cling film into the wet paint. Leave to dry under pressure before removing the cling film.

interesting, if unpredictable, results. Screw up some cling film (plastic food wrap) and lightly press it into the wet painted surface. Then put a book or some other form of weight on the cling film to hold it in place, and leave to dry before removing the cling film.

Spattering

This technique produces a fine, speckled texture. It is a method I sometimes use during the painting process to create a mottled, diffused colour quality (by spattering into wet paint), or at the end of a painting to add highlights and texture effects, often with white ink. You can use an old toothbrush or stiff-haired brush for this. Dip it into some paint, hold it directly in front of the area you wish to treat, and pull back the bristles with your forefinger to produce a shower of fine spray. Alternatively, tap the brush against your finger or a pencil. Before using this technique you should experiment to ensure the brush and paint consistency you use will produce droplets of the size and distribution you want.

Spray

I use an inexpensive, small plastic spray bottle for this technique, although you could also use a spray diffuser or airbrush. The spray bottle contains some clean water and I either spray this onto the paper first and then add colour, or I apply the colour first and, while it is still wet, spray it with some water. I find this a particularly good technique for foliage and flowers. You could, of course, use colour wash instead of clean water in the spray bottle.

Dry-brush

Try this technique on some Rough-surface paper. Preferably use a dry, flat or stiff-haired brush that is only lightly charged with paint. Drag the brush gently across the paper so that it just catches the surface and leaves a patchy, broken area of colour.

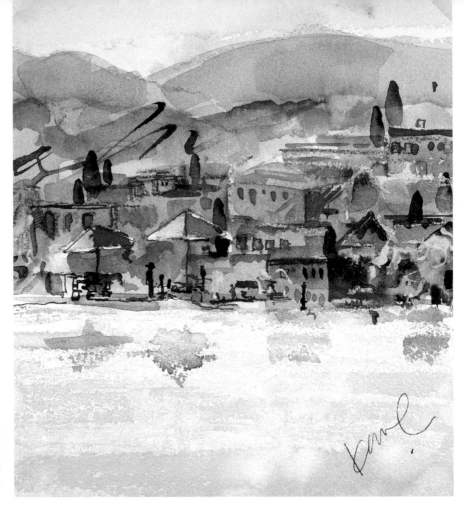

Wax Resist

If you lightly block in an area of your paper with candle wax or a wax crayon before applying a colour wash, the result will be the sort of texture shown in the foreground area of *Red Shades* (above).

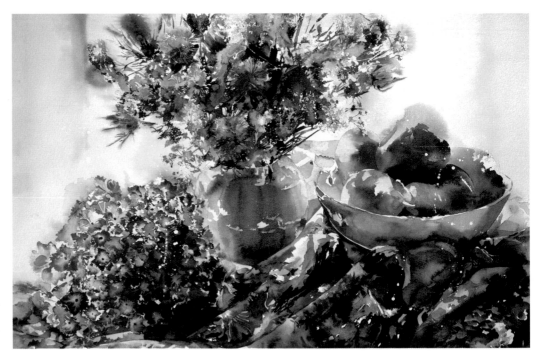

Mixed Media and Experimental Techniques

In *Early Evening, Italy* (page 8) the initial drawing was made with felt tip pens, while for *Como* (page 27) I have included some pen-and-ink work, and in *Final Shore* (page 31) there are splashes of white ink. I quite often use a mixed media approach with watercolour. In my studio I have a variety of drawing and painting media available, and if I feel that an idea will benefit from a few charcoal lines, some wax crayon textures or whatever, then I am happy to use them.

Similarly, I enjoy experimenting with watercolour's different strengths and qualities. In *Passing By* (below), for example, there are some interesting paint effects that I managed to create by tilting the board and allowing the paint to flow and run in various directions. I have let the paint bleed and fuse into the surrounding area in *This Morning's Flowers* (page 36), while in *Beach Boredom* (page 38), a small study, the painting was much improved and enlivened by the addition of some final sweeping splashes of colour.

Passing By
53 x 71 cm (21 x 28 in)
To create the sort of background effect I wanted for this work I tilted the paper and let the watercolour washes run and flow in various directions.

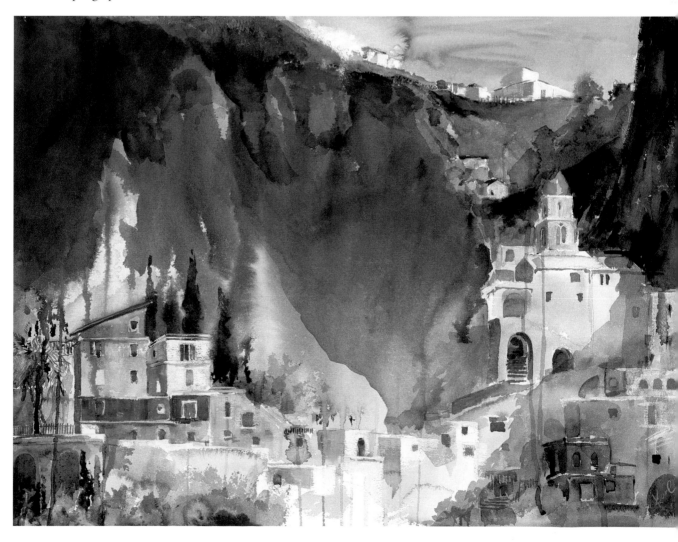

Puddles at Syon
76 x 51 cm (30 x 20 in)
Mostly I have used wet-on-dry and wet-into-wet techniques for this painting, but as you can see in the floor area, I have also allowed the paint to run in places to create the effect I needed to suggest shadows and reflections.

Beach Boredom
9 x 13 cm (3½ x 5 in)
Sometimes just a few confident, sweeping brushstrokes can really enliven a painting.

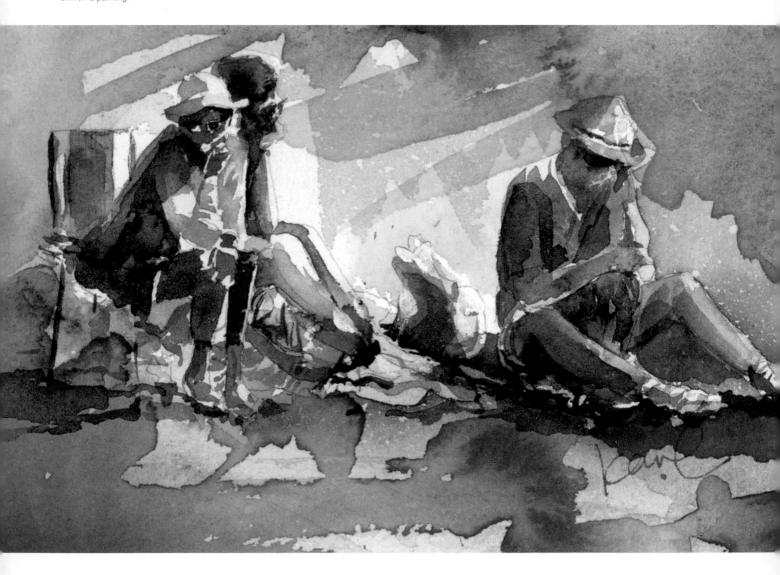

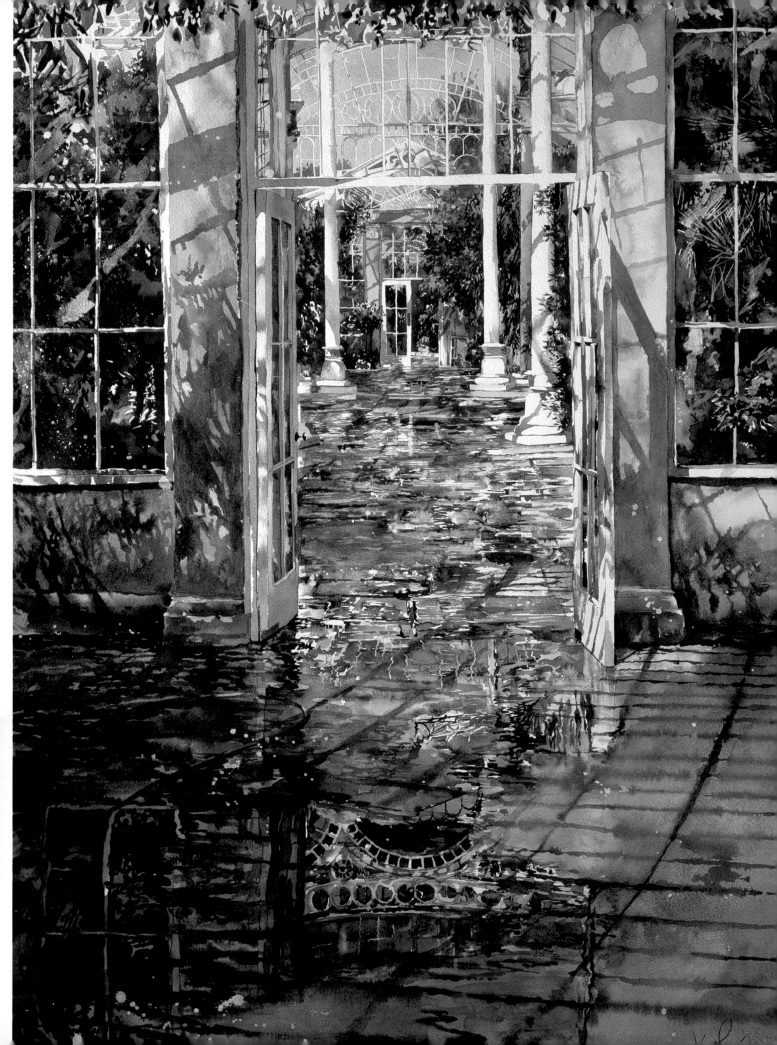

2 | Vibrant Colour

Colour can be a powerful, emotional quality in a painting and usually, whatever subject I choose, it will be the impact of colour that I want to focus on most. The reason I am attracted to certain types of subject matter is because they instantly excite me with their bold coloured shapes and relationships, and I see a potential to exploit this in a painting. I like vibrant colours, and mostly I find these in the Mediterranean rather than in the UK. In Britain the colours are much more subtle – and indeed, this is their beauty. But perhaps I am not a very subtle person, because I find pale colours quite difficult to handle!

When I first started painting watercolours I worked exclusively from still-life subjects. With still life, of course, you select and compose the subject matter yourself, and it is interesting that even at this stage I invariably chose ideas that were rich and bright in colour. Later, when I had more space and was able to work on a greater variety of ideas, I found that I was instinctively attracted to subjects in which colour was the most important aspect.

Exploring Colour Theory

Some people seem to have a natural affinity for colour and, for example, have no trouble in creating the perfect colour scheme for the décor and furnishings of a room. Painting requires a similar approach. It is a matter of using a group of colours that together will express the particular mood and other attributes of the subject that you feel are significant. In time, assessing which colours to use becomes largely an instinctive process that develops from accumulated knowledge and experience. Usually, a contributing factor to that experience is an awareness of the basic colour theories and exercises.

Most aspects of colour theory are based on the premise that there are three primary colours, which for a process such as painting are red, yellow and blue (additive processes such as colour photography have a different set of primaries). By combining and mixing these in various

Top Pots
56 x 76 cm (22 x 30 in)
This simple composition has tremendous impact, due to the bold use of colour and shadows.

ways you can make practically any colour you wish, although both white and black lie outside the range of colours that can be produced from the primaries. In manufactured paints, however, 'pure' primaries do not exist and so, in practice, it is not possible to mix every theoretically available colour with total accuracy, although we can get very near.

Imagine these primaries arranged on a disc – a 'colour wheel' – spaced equally a third of the wheel's circumference apart. By mixing two primary-colour paints together you create a secondary colour (green, orange or purple), which occupy the spaces on the wheel midway between their parent primaries. Other terms to be aware of initially are complementary colours (those opposite each other on the colour wheel) and analogous colours (those that are next to each other on the colour wheel, and thus regarded as harmonious). The best way to understand these terms is to make a colour wheel for your own reference, and to try various colour-mixing exercises. One principle to bear in mind when mixing paint colours is that the mixture is always darker than the component pigments. Like everything to do with painting, your knowledge and ideas about colour will grow step by step with each painting you complete.

Above: Making a colour chart like this will be a good reference for identifying different colours and colour mixes.

Colour Families

Having found a subject that I want to paint, I then make a judgement as to the colour palette (the range of colours) that I am going to use. My approach to this is to think in terms of colour families – that is, a certain selection of colours that will not only help me express the particular qualities that I have in mind for the painting, but will also create a

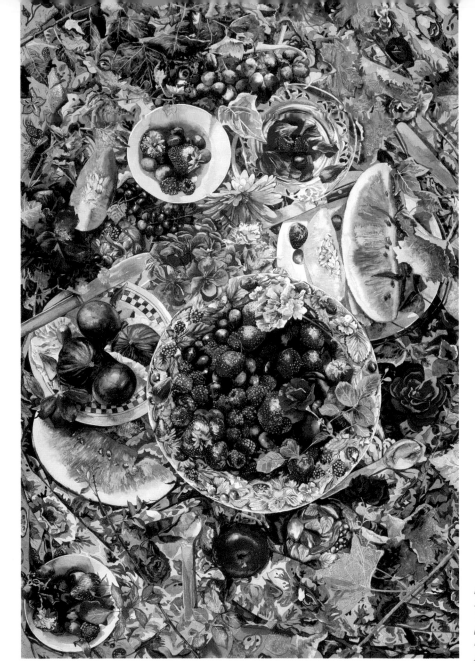

harmonious, integrated colour effect. Generally, a colour family will relate to what is alternatively referred to as the colour key of a subject. In other words, are the colours essentially warm, cool, neutral, bright and so on?

For example, in *Hunt the Thimble* (above), the colours are mostly reds, yellows, oranges and rich purples, and thus the overall effect is of a warm colour sensation – even the greens have a warmth to them. Contrastingly, in *No Word about the Mountain* (page 45), the range is limited to cool colours. Other paintings on pages 44–46 demonstrate the use of bright, neutral, rich and earth colours. As you can see, the advantage of keeping to a certain colour family is that it gives the finished painting a unity and clarity. If many different colours are used the result can be jarring and disconcerting. I think *Terrace and a Pool Below* (page 44) demonstrates this point. I have been too ambitious here – the painting would have worked better with fewer colours.

This is not to say that the colour must be totally even in its richness or coolness throughout the painting; that there cannot be elements of

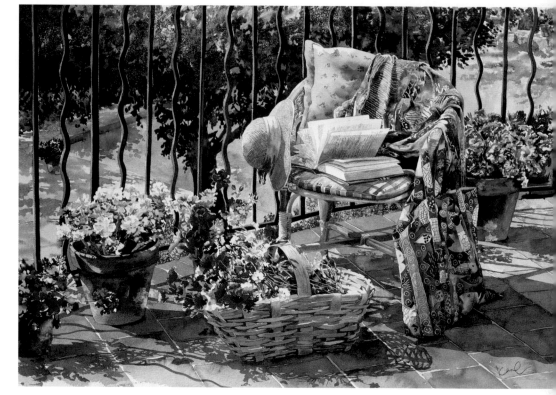

Terrace and a Pool Below
46 x 69 cm (18 x 27 in)
*Too many different colours will create
disunity and in fact lessen the impact
of the painting.*

The Natural and Human World
41 x 71 cm (16 x 28 in)
*I think it is often necessary to
exaggerate colours in order
to successfully convey the effect you
have in mind. Here, I wanted to create
a feeling of the warmth and
colour of Italy.*

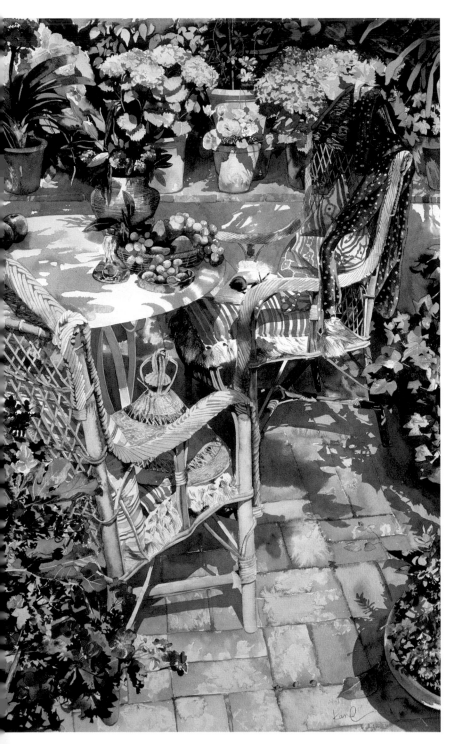

Red Spotty Scarf
71 x 51 cm (28 x 20 in)
Here is another example in which a limited selection of colours gives the finished painting a unity and clarity.

No Word about the Mountain
71 x 48 cm (28 x 19 in)
In contrast, this range of colours creates a cool, subdued effect.

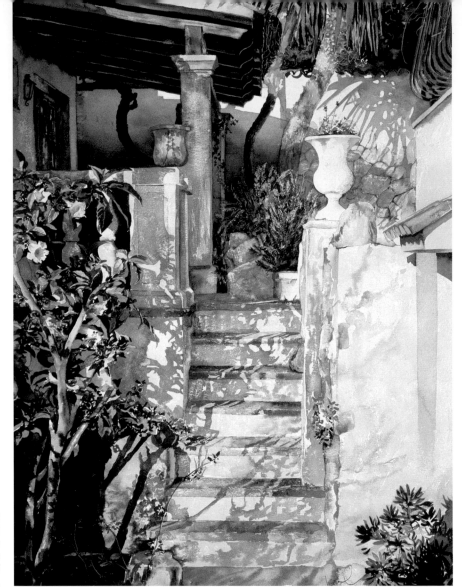

Steps to the Pool
48 x 33 cm (19 x 13 in)
The colour harmony in this painting comes from a neutral range of greys and blues, with muted greens and browns.

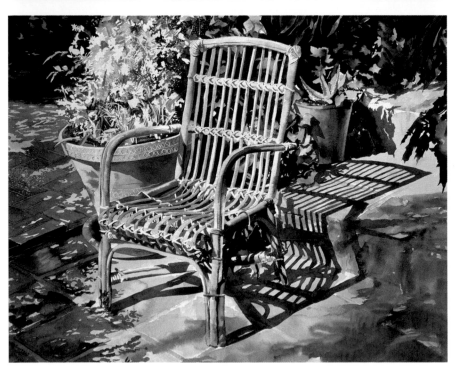

Old Andalusian Chair
38 x 48 cm (15 x 19 in)
These are mostly earth colours, which produce a quiet, subdued quality.

contrast. In fact, some areas of contrast are essential if the painting is to have any sort of visual impact. But I prefer to do this by means of tone – different light/dark values of the same colour – rather than by introducing distinctly contrasting colours.

Limited Palette

For most paintings I start with my full range of colours (see page 22), even though I intend to keep to a certain family of colours. Generally I like to have all the colours available in case they are needed for specific colour mixes. Very occasionally, however, I restrict the palette to just a few colours, as in *Bamboo Garden, Marrakech* (below), although this is not an approach that I usually find very satisfying. For me, it is like having one hand tied behind my back! But I appreciate that for some artists it is a good discipline and there are useful points that can be learned from it.

Essentially, whether using a limited palette or a more extensive range of colours, I am responding to the colours that are actually there, rather than inventing a colour scheme. As I have said, I sometimes exaggerate certain aspects of the colour quality or intensity, but in my view, if the colours 'work' in the subject matter as found, then they should work even better in a painting. So the impact and potential of colour within a subject are qualities that I look for right from the start when I am choosing something to paint.

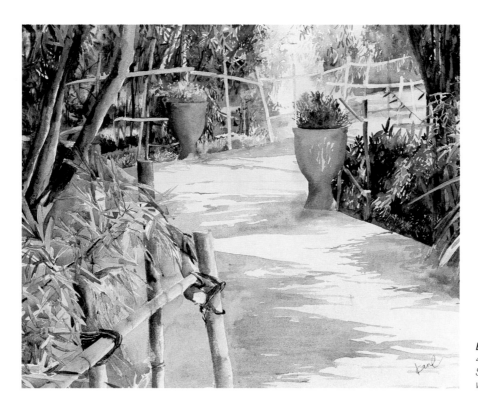

Bamboo Garden, Marrakech
43 x 53 cm (17 x 21 in)
Sometimes it is worth experimenting with a very limited palette of colours.

If you find it difficult or confusing to handle different colour properties, harmonies and relationships successfully, then a limited palette approach could be a good idea. By selecting perhaps only four or five relevant colours (chosen to suit the overall mood and colour key) you will automatically gain greater control of and confidence in your use of colour. Moreover, such an approach can also help your skills in colour mixing. In fact, it is surprising just how many different colours you can mix from a limited palette, and theoretically these should all contribute to a basic harmony and unity.

Expressive Colour

The way that we react to colour depends on a number of factors, not least that we each have a different sensitivity to particular colours and colour relationships. Equally, painting styles vary from one artist to the next, as do the aims for painting and the significance that is placed on certain qualities and effects. Most artists begin with observation, but the method of interpretation from there on is influenced by individual skills and modes of expression. With colour, of course, you can adopt an entirely representational approach and choose to reproduce the colours faithfully as seen, or you can work in a much freer way based on your personal feelings and responses to the colours.

Observation is important, not just to notice the actual colours, but also to see how colours interact and create the effects and sensations that characterize the subject matter. So it is a good idea to begin by spending some time just looking and assessing. Then, with a knowledge of what is happening in terms of colour, you are better able to decide which colours you need to suit the approach you want to take.

When making the initial assessment, try to view colours without any preconceptions, as if you were seeing the objects for the first time. For example, in a landscape it is very easy to assume that a field or grassy bank is just a patch of green, whereas a close analysis might show that the colour content is actually much more exciting and varied. This sort of observation can greatly enhance a painting, especially if it is interpreted by employing a suitably interesting technique. In *Strange Changes* (right) I used a wet-into-wet technique for the principal areas of green and blue, relying on both accidental and controlled effects. Also, notice how I have used bold colour and a loose, expressive approach here.

It could be just a small patch of striking colour that initially attracts you to a subject, and most likely this will be an area of what is known as 'local colour' – that is, colour unaffected by such factors as shadows, reflected colour from surrounding objects, and so on. This will give you an indication as to the colour key of the subject, and from that you can start to make judgements regarding the sort of mood and impact that

you want the colour to convey. In considering which colours to use, bear in mind that as well as exaggerating some colours, you may have to alter, simplify or disregard others.

Emotional Response

I love colour: it always creates an emotional response in me, and certainly this is something that I hope is reflected in my paintings. When people view my work I especially want them to react to the way that I have used colour, and the colours that I like most are those that have the greatest emotional impact. For example, I often paint subjects in which there are strong oranges and blues, as in

Strange Changes
28 x 48 cm (11 x 19 in)
Different colours suggest different moods. These dark blues and greens convey a disturbing, stormy feeling.

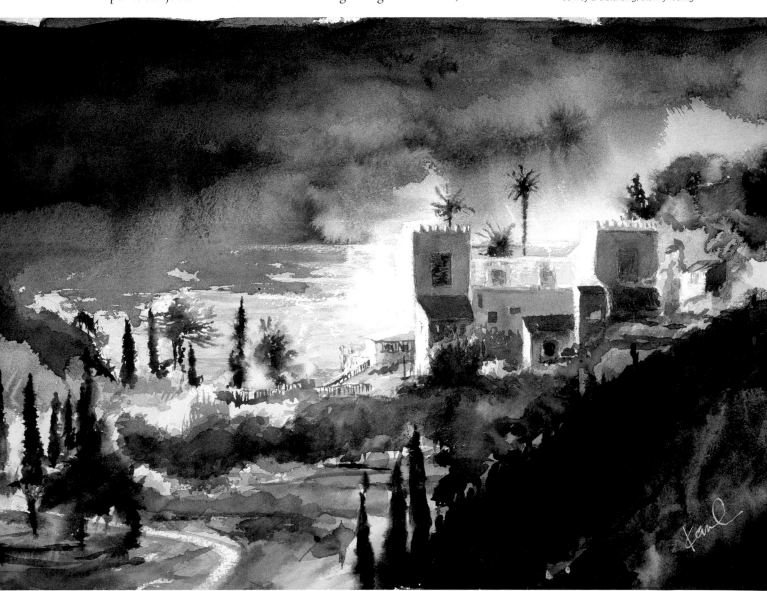

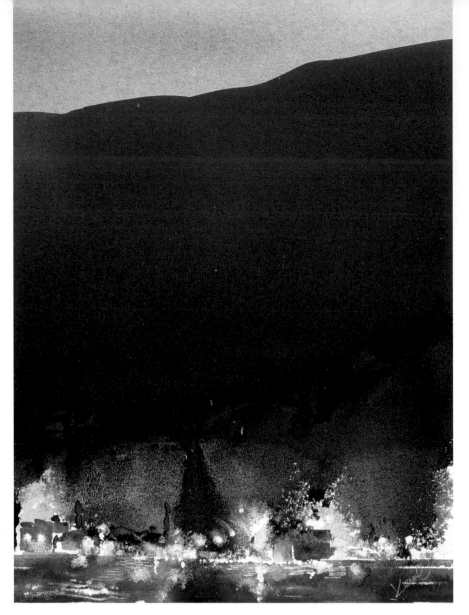

The Sun Goes Down I
30.5 x 20 cm (12 x 8 in)
*I like colours that have a strong
emotional impact and I am particularly
fond of pure or only slightly modified
blues and oranges.*

The Sun Goes Down 1 (above). These are very powerful colours if applied in a pure, unmixed form, or only slightly modified, and particularly so when only the best, artists-quality paints are chosen. Moreover, because these colours are transparent, they can be used in quite a thick consistency, which is my preferred method.

Obviously the degree of emotional impact that a painting creates depends on the specific choice of colours, their relative positioning and importance within the composition, and their effectiveness in a technical and physical sense. Indeed, no colour can be selected and applied without giving consideration to the rest of the painting: every colour plays its part towards achieving the desired aims and qualities. *In Sunset Still Life* (above right), for instance, the colours are bright, and the choice and combination of colours result in a painting that is cheerful and full of energy. On the other hand, in *The Wilderness Garden* (right) the neutral earth colours create a more subtle, calming effect.

You could argue that an emotional response is far more difficult if you are not working on the spot but, as I do, referring to photographs. It is true that photographs cannot record feelings and emotions – those are captured in the memory of the artist. What is important therefore is that

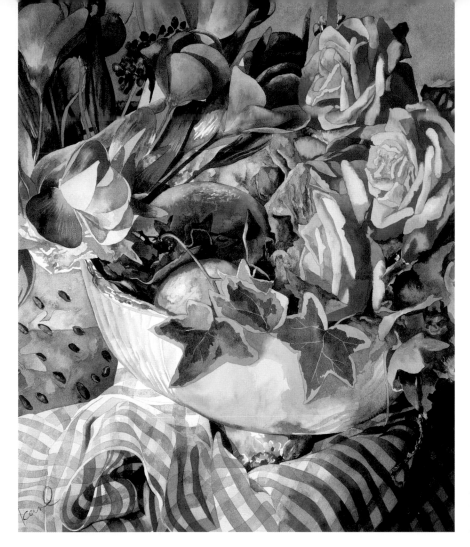

Sunset Still Life
34 x 29 cm (13½ x 11½ in)
These bright colours create a cheerful, vibrant quality.

The Wilderness Garden
43 x 63.5 cm (17 x 25 in)
The choice of colours is very limited in this painting – restricted to earth colours, which give a quiet, sophisticated effect.

you take your own photographs, and consequently are painting subject matter that you yourself have experienced. You are then able to be selective about the composition and other information, by using the photographs in conjunction with your own ideas, memories and imagination. In my view, therefore, a photograph is never simply

something to copy. Also, as I have explained on page 85, it is best not to rely too much on photographic references until you have had some real experience of observation and sketching directly from the subject matter.

Colour and Design

Especially in paintings where the colour has an obvious and powerful presence, it must also work in terms of the composition. This is because the balance and contrasts, the patterns and rhythms of colour will greatly influence the way that the painting is 'read' and understood – how the viewer's interest is contained within the painting and directed around it. The placing and relationship of intense and subtle colours, the repetition of certain colours, and the use of complementary and analogous colours

Carnival Nemesia II
58.5 x 39.5 cm (23 x 15½ in)
Here, I have used what I would term a bright family of colours.

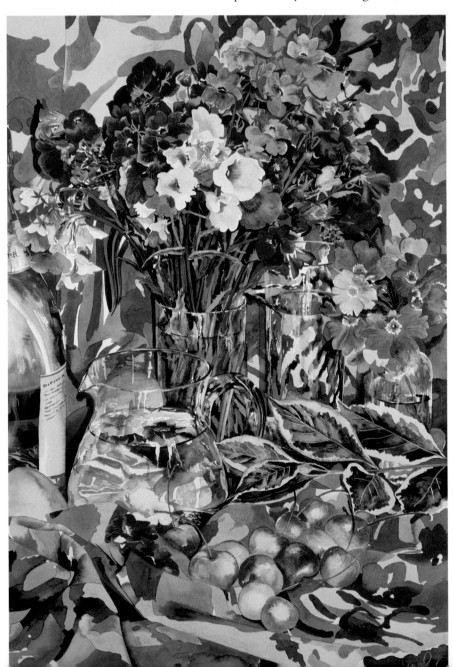

Italian Sham
50 x 74 cm (19½ x 29 in)
As well as its other properties, colour contributes in an important way to the basic design of a painting. In this work, note how the strips of complementary colours, in purple and yellow, emphasize the strong vertical and horizontal lines of the composition.

all contribute to the dynamics and impact of the design and its general success in conveying the artist's intentions.

This is not something that can be planned to the last detail. For if it is too contrived then the colour/composition relationship will lack vigour and look false and awkward. Ideally, like so much to do with painting, it requires a more spontaneous, intuitive approach, although perhaps also combined with a certain amount of trial and error. In watercolour, of course, there are great limitations when it comes to modifying or reworking colours, so if you have doubts about the choice of a certain colour, or the combination of adjacent ones, first test out the colour or combination on a scrap piece of paper.

I used to work more from drawings and other information gathered on site. But now that I paint mainly from photographs I am, in effect, choosing the colours and design right from the start. Sometimes it is essentially colours and shadows that create the design, as in *Top Pots* (page 40). In other paintings the design may be enhanced by, or rely on, the use of complementary colours or similar effects that are the result of exaggerating or developing qualities found in the original subject matter. Note how the strips of purple and yellow complementary colours in *Italian Sham* (above) emphasize the strong vertical and horizontal lines of the composition.

Another aspect of colour in relation to the composition is how it can be used to convey the idea of space and depth. In general, warm colours

Bench at Alfabia
56 x 71 cm (22 x 28 in)
This is an honest representation of the colours that were there. If the actual subject matter has attractive, harmonious colours, then those in the painting should be likewise.

Vibrant Colour 53

Syon Square
69 x 66 cm (27 x 26 in)
Colours also help convey a sense of
depth. Warm colours attract attention
and come forward, whereas cool
colours recede.

stand out and come forward in a painting – and are therefore useful in the foreground – whereas cool colours tend to recede. This is a characteristic that I have made use of in *Syon Square* (above).

Mixing Colours

As explained on page 21, while all watercolour paints have certain characteristics in common, there are differences in the degree of staining power, tinting strength and other qualities. These differences become more apparent when the colours are mixed and subsequently applied to the paper. For example, colours such as cadmium red and ultramarine blue have a high tinting strength, which means that only a small amount of pigment is required when mixing a wash or intermixing with other colours. It is obviously an advantage to know how different colours respond, and the way to do this is through practical experience.

There are times when I use colour straight from the tube, but only when there is no way of mixing a specific colour – perhaps an unusual colour for a flower, for instance. Otherwise all my colours are mixed. For my detailed, controlled style of work I mix small amounts of colour, as I use it. With the more expressive, experimental paintings I mix larger quantities and different consistencies of paint, though I rarely use what could be described as the traditional 'wash'. I only ever mix two colours together to create the particular colour I need, and I avoid cross-mixing between families of colours (see page 42). This is the best way to avoid muddy colours, I think.

It is also important to work with clean brushes and water. You can reduce the tonal strength of a colour by adding more clean water and,

Mesa Yialos
48 x 66 cm (19 x 26 in)
A dramatic viewpoint can add to the impact of colour.

conversely, you can enrich or modify a colour by adding a little more pigment. If a colour is too intense, dull it down by mixing it with its complementary colour – for example, if a red it too bright, add some green.

Colour Matching

Some people have a natural ability to judge colours and they know exactly which combination is required to create the right colour mix. However, if this is something that you find difficult, then you may need to work mostly on a trial-and-error basis, first testing out the colour mix on a piece of scrap paper. But remember that it is important to keep the colours fresh and transparent, so avoid modifying the colour mix too much – start again if necessary. If you are working on site or directly from a still life or similar studio subject and you want to match a colour, then try holding the test piece up to the subject to make a comparison.

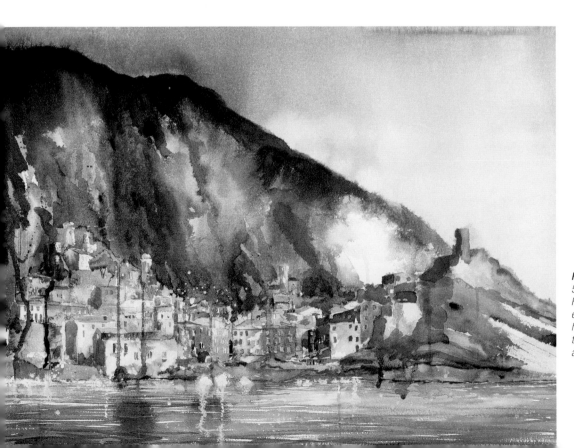

Red Italy
53 x 74 cm (21 x 29 in)
Here again, the colours have been exaggerated, this time to capture the heat and earthiness of a place where the building colours were terracottas and creams.

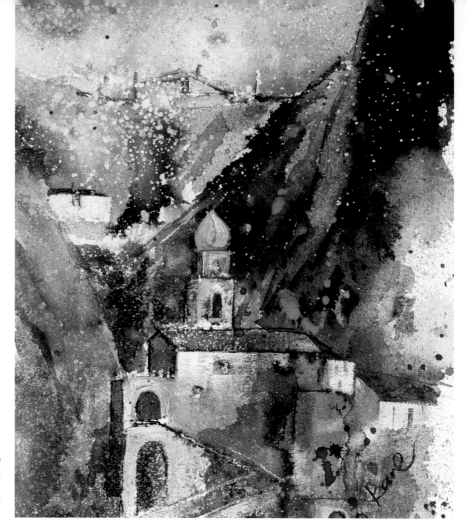

Having said that, there is clearly also a subjective element to colour, and not every painting has to be tackled in a totally representational way. You may want to exaggerate or invent colours, in which case only you can decide whether the colour you have mixed is sufficiently like the one you have in mind. Indeed, sometimes it is fun just to use whatever colours take your fancy, as I have done in *Amalfi I* (above).

Darks and Greens

I never use black. It is what I would describe as a 'dead' colour and my advice is to avoid it. You can produce quite a range of interesting dark greys by mixing earth colours with blues, although be careful not to add too much earth colour, or you will make a brown. Burnt umber and cobalt, for example, will give a deep grey when mixed in equal proportions. In fact, mixing an intense dark from just two watercolour pigments is impossible. But with three colours, such as vermilion, ultramarine and cadmium yellow, you can create an effective green-black, while ultramarine and burnt sienna gives a warm, transparent near-black.

Green is not a favourite colour of mine, although obviously it features in many of my landscape, garden and still-life paintings. Often the difficulty is mixing a green that at the same time conveys a particular quality of light. For instance, green is a bright and limey-yellow colour when sunlight shines through a leaf. But when the sun shines off the leaf's surface it is more of a blue-green, and when the leaves are in deep

shade the effect requires a turquoise-blue with perhaps even a touch of body colour added. I do include some greens in my palette, but I usually modify them with blues and yellows.

Green is a challenging colour because it can so easily become vibrant and dominant. Each artist has his or her own recipes for mixing greens, and as with any colour mixes, the best way to gain some confidence is through experimentation. Try various combinations on a sheet of paper, noting down how they were made and keeping them for future reference. Also remember that the proportion of each blue and yellow that you used in a mix will influence the sort of green you create. Cadmium yellow and phthalo blue, gamboge and cerulean blue, lemon yellow and French ultramarine, and aureolin and indigo are some of the mixes you could try.

Garden Arch
66 x 43 cm (26 x 17 in)
Greens are always best mixed, rather than used straight from the tube. I do use some greens in my palette, but usually modify them with blues and yellows.

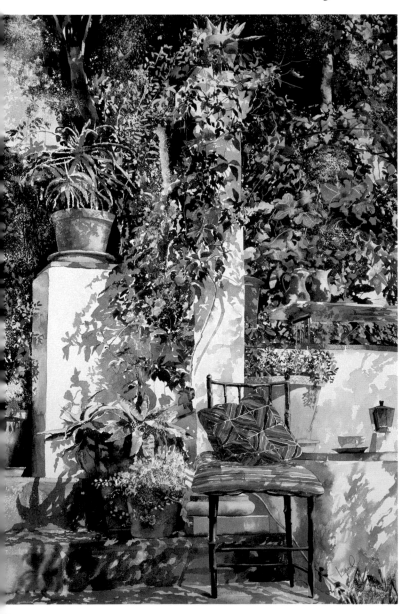

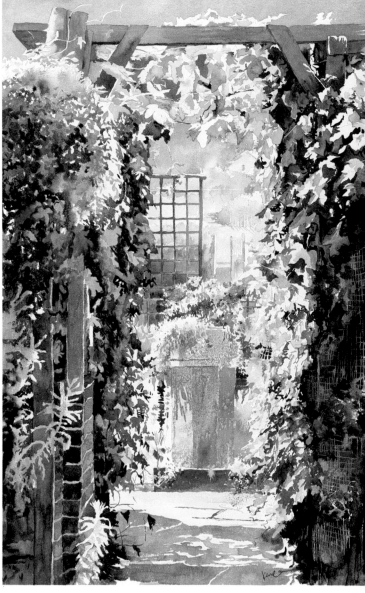

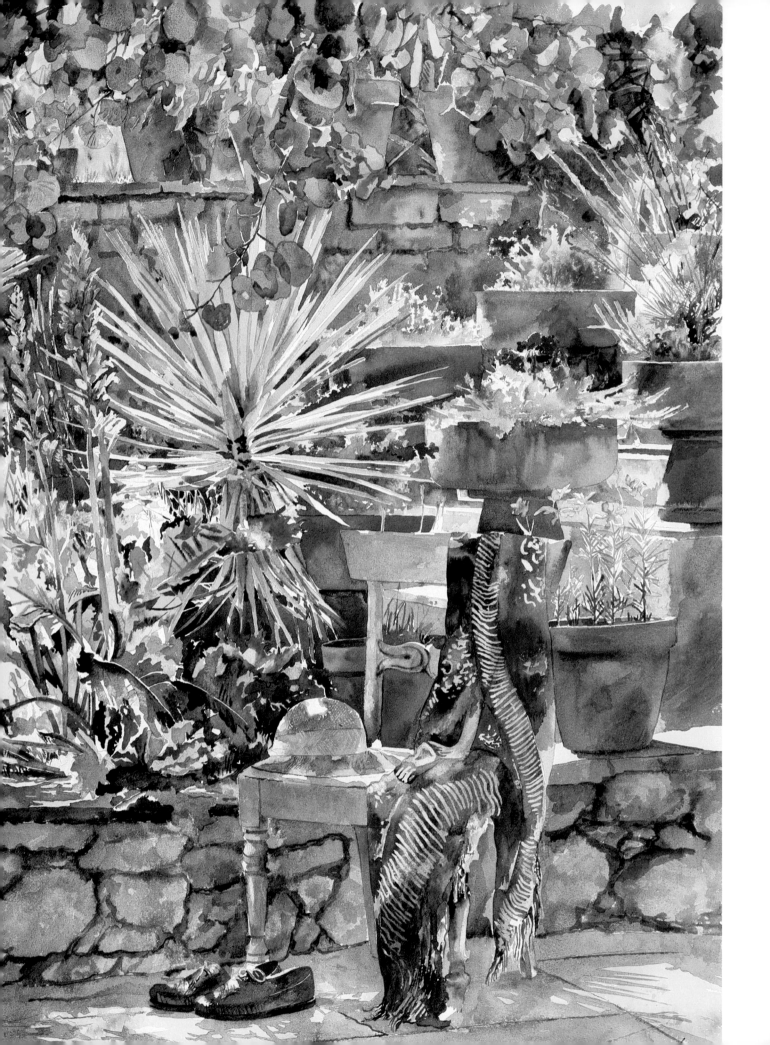

3 | Sunlight and Shadows

So far I have stressed the importance of colour in my work, but without much reference to the influence of light and the way that colour and light relate to each other. In practice, when I find a subject that appeals to me, as well as considering the impact of colour I also take note of the particular type of light at the scene, and how this enhances, subdues or otherwise modifies the colour. Indeed, sometimes it is the light effect itself that has the greatest significance, and the colour is secondary. But in general the two are inseparable, because colour is entirely at the mercy of the light that is cast upon it. Consequently, with intense light the colours are warm but pale, while subdued light results in dark, sombre but richer colours.

Colour and Light

Many artists concentrate on capturing a particular quality of light in their paintings, and use colour as the means to interpret that quality. I also adopt this approach at times, but in the majority of my watercolours I work the other way round. In other words, I want the emphasis on colour and I use the light effect to reinforce this. For me, the feeling of light is always important, though primarily in the way that it reveals the mood and drama of the colour.

Like colour and composition, the lights and darks in a subject are one of the features that I initially look for and assess. There are two types of subject matter that I find especially interesting: subjects in which there is a strong contrast of tonal values and, at the other extreme, those where the light is fairly even and thus encourages an emphasis on the pattern and rhythm of the colours, as in many of my still-life paintings. Good light and dark contrasts are created when a subject is lit by strong sunlight, as in *Two Apples* (page 60); by controlled artificial light, as in *Irises at Night* (page 60); or perhaps through pure imagination and invention, as in *When We Last Saw the Sun* (page 61).

Eddie's Shoes
76 x 51 cm (30 x 20 in)
Although there is a strong sense of sunlight here, the cast shadows are more subtle and evenly distributed.

Two Apples
51 x 76 cm (20 x 30 in)
Viewed in strong sunlight, this subject
had obvious contrasts of light and dark.

Irises at Night
48 x 74 cm (19 x 29 in)
Artificial light can be controlled to give
interesting tonal contrasts.

When We Last Saw the Sun
47 x 54 cm (18½ x 21 in)
Sometimes I like to invent or distort the lighting effect to create a real sense of mood and drama.

Suffolk Dusk
56 x 76 cm (22 x 30 in)
Here the light is fairly even, so the tones are soft and atmospheric.

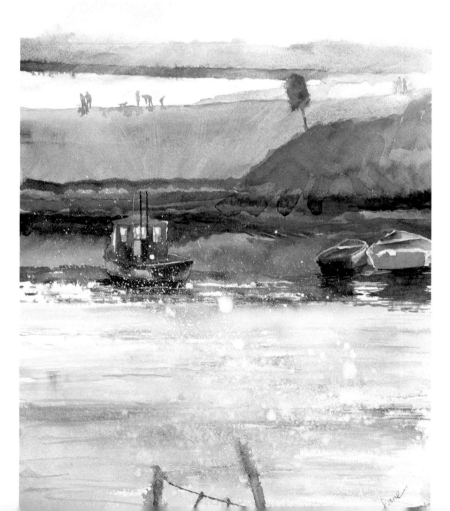

Observing Light

Whatever the subject, before you can consider colour it is a good idea to look at what happens concerning the light. Usually the best approach is to start with an assessment of the tonal scale (the range between the lightest and darkest tonal values) and note how the various lights and darks are distributed. From this you should be able to decide whether you need to exaggerate the tonal contrasts, or can accept what is there. In most cases some exaggeration is necessary in order to give the painting sufficient impact and interest. To help judge the subject in terms of tone rather than colour, try viewing it through half-closed eyes.

If you are new to painting in watercolour, you may find it useful to start with a small tonal pencil sketch as a means of identifying and recording the key lights and darks. Additionally, this will make an excellent source of reference when you begin work on the actual painting, showing you where to place and develop the various tonal contrasts. Small sketches are also useful, among other things, for observing and understanding the subject matter, and helping you organize your thoughts regarding the sort of composition you want.

For these reasons I believe sketching is a beneficial exercise, but as soon as you feel confident about assessing a subject and seeing it in terms of tone, preliminary sketches become unnecessary. In fact, it is not a technique that I have ever used – I have always been eager to get straight on with the painting!

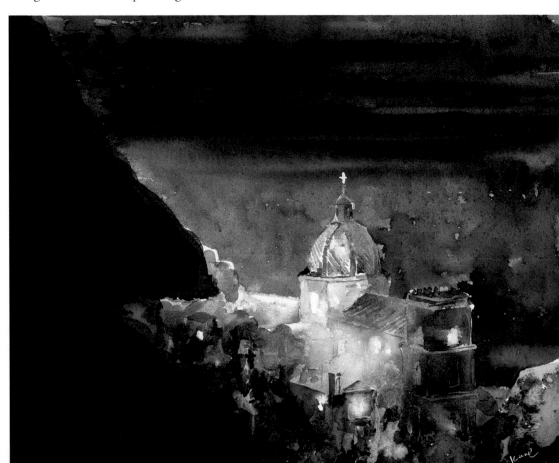

Church By Night
36 x 41 cm (14 x 16 in)
Again here I have exaggerated the light effect to enhance the impact of the painting.

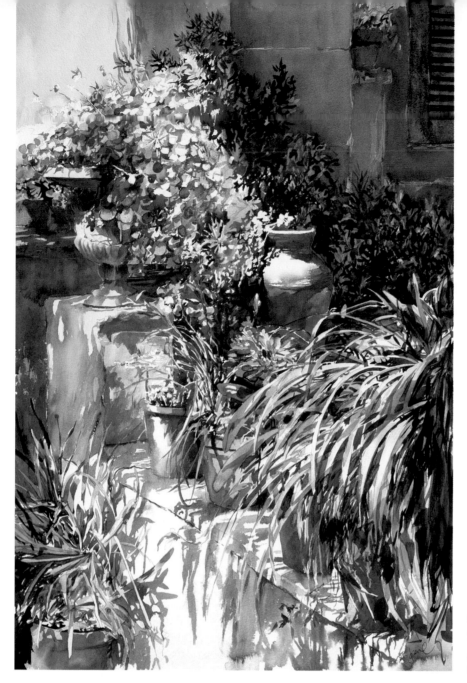

Hot Pots, Bright Light
71 x 48 cm (28 x 19 in)
The strong Mediterranean sunlight creates very distinct highlights and shadows.

The tonal values in some subjects are much easier to appreciate and interpret than in others. In *Hot Pots, Bright Light* (above), for example, the scene is lit by strong sunlight and the tonal contrasts are clearly defined. Equally, there is an obvious sense of sunlight in *Eddie's Shoes* (page 58), although here the cast shadows are more subtle and evenly distributed. So how can you achieve the right strengths of tone in a painting?

One of the first things you discover about watercolour painting is that if you make an area too dark in colour, there is no way back. In other media, especially in oils and acrylics, you can easily remove paint, rework areas, or paint over them when dry. None of these techniques is very successful in watercolour. If you do try lifting out or repainting areas, then usually the paper surface is damaged to some extent, or the colour looks miserably thick and opaque.

In subjects where you want a strong contrast of tones there is no problem, because you can always make things darker. Where the light

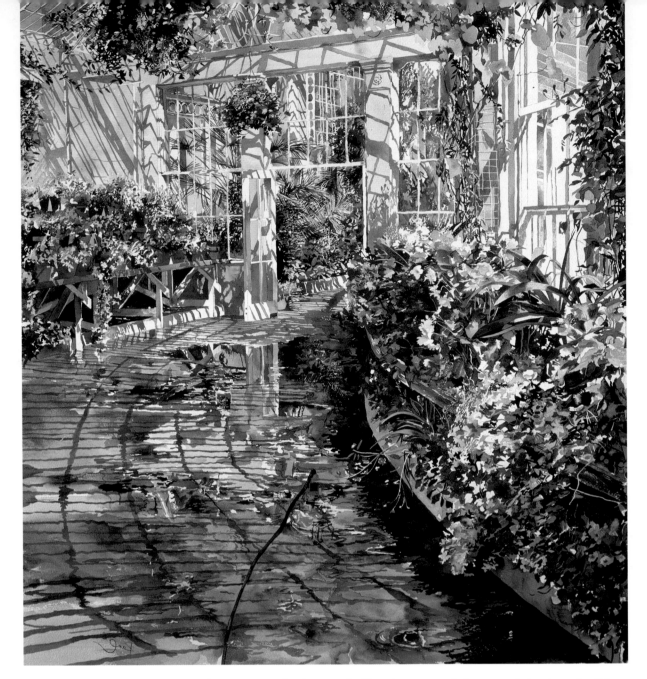

Conservatory
66 x 56 cm (26 x 22 in)
*Always work from light to dark, and
be careful not to make the intense
shadows too dark too early.*

and consequently the tonal effect is more subtle, my advice is to build
up the tones slowly, starting with the very weakest ones. The traditional
wash-over-wash approach works best here. In other words, having
applied an initial weak wash to all areas except the strong highlights
(which are left the colour of the paper), you let this dry and then add
a further layer of wash to those parts that are slightly darker in tone,
repeating this process until you have built up the required variations
of light and dark.

Interpreting Tonal Values

As I have mentioned, tone is the relative light/dark strength of a colour.
There are two ways in which this is achieved. An individual colour, such
as green, can vary in its tonal value from a weak, pale tone, perhaps
when seen in strong lighting conditions, to a really intense dark, when it

is in shadow. As well, each group of colours has an inherent general tonal value. Yellows, for example, are naturally light-toned colours, while most blues are of a mid-to-dark tone.

When painting, both types of tone have to be considered. You can juxtapose certain colours so that they convey tonal contrast – placing a pale lemon yellow next to a purple, for instance – and at the same time you can model the form of objects and suggest depth by creating a transition from light to dark tones within the same colour.

Adjusting a colour to match a certain tone is never just a matter of adding white or black, of course. In watercolour, the tone of a colour is made weaker by adding more water, and stronger by adding more pigment. Alternatively, you can also change the tone by altering the proportions of the two colours used in a certain mix (when they have contrasting inherent tones), or by adding a touch of another colour. Mixing a small amount of violet into a red, for example, will make the red darker in tone, while adding some yellow to a green produces a lighter tone. Look at the table, pots and other objects in *Crates* (below) and notice how the variations of tone bring out the sense of form and space.

Light and Form

Another important quality of light is the way that it conveys a feeling of depth and describes the shape and form of objects. This is a quality that I like to exploit in many of my paintings, particularly those of Mediterranean subjects, which invariably are lit by strong sunlight and

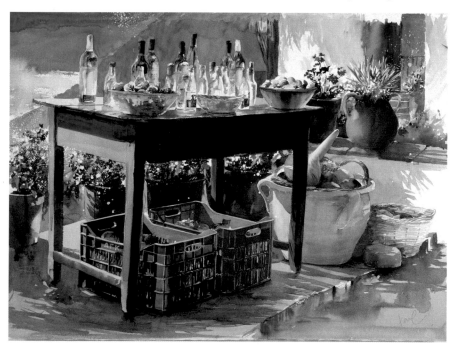

Crates
53 x 74 cm (21 x 29in)
Notice how the contrasts of light and dark emphasize the three-dimensional form of the different objects in this painting.

therefore contain good tonal contrasts. Often I choose subjects that feature a positive, directional light, and consequently include interesting cast shadows. However, with light, as with any aspect of painting, the manner of interpretation is entirely at the discretion of the artist, and sometimes I adopt a very different approach, as is evident if you compare *English Garden* (right) and *The Bench and the Balustrade* (below right).

Light can add drama to a painting in much the same way that it does in a stage play. Indeed, in that sense, because I tend to emphasize the tonal contrasts, many of my paintings do have a 'stage-lit' quality. For most of my work the reference for the lighting is from photographs. Again, as with colour and composition, I start by assessing the effectiveness of the lighting in relation to the overall impact of the subject matter before taking any photographs. In many instances a single photograph will encapsulate everything I need to know about the subject matter, although obviously I may adapt things. Essentially, I am trying to identify subjects that will work as paintings more or less in the form that I find them.

One of the advantages of taking a photograph is that you capture the lighting and other qualities instantly, and so you can record them exactly as they are seen at a given moment in time. Natural light never stays the same for very long, and this can be a problem if you decide to work

Hill Village
23 x 25.5 cm (9 x 10 in)
Buildings in a strong light look more solid, showing a light side and a dark side.

directly from the subject matter. But never try to 'chase' the light – in other words attempt to alter the light effects in your painting to suit the changing light conditions in the subject matter. Instead, if you prefer working on site, it can be useful to start with a quick tonal sketch to use

English Garden
56 x 76 cm (22 x 30 in)
With the absence of any obvious cast shadows this subject had a flat, decorative appearance, which I enjoyed exploiting.

The Bench and the Balustrade
66 x 66 cm (26 x 26 in)
It is the wide variety of tonal contrasts, more than the colour, that adds the interest and impact in this scene.

Squash (right)
53 x 38 cm (21 x 15 in)
The strong tonal contrast between foreground and background helps create an immense sense of space in this painting.

as a reminder of the lighting effect that you want to capture in your painting. In any case, try to identify the principal lights and darks in the painting as soon as you can. In a landscape, the sky is usually the area that will tell you most about the light and mood, so start with this.

Pictorial Space

You can also use changes of tone (in conjunction with perspective, relative scale and so on) to suggest depth in a painting. Generally, when you look at a subject and start to analyse the different tonal values, you will notice that the strongest tones and richest colours are in the foreground. The further you look into the distance, the more the tones and colours become subdued and less defined (a phenomenon known as aerial perspective). There are exceptions, of course, for example in *contre-jour* (literally, 'against the day') scenes, which involve looking into the sun. But this type of tonal contrast is something to bear in mind, especially if you want to create very realistic paintings.

Depending on the subject matter, I may decide on a flat pattern approach, or I may opt for something more conventional. These two approaches tend to be quite extreme as far as the use of tone is concerned. For me, where there is an even light and a flat pattern effect, tone is not a consideration – I want to focus solely on the pattern and colour qualities. But where there is a strong light and good tonal contrast, I like to emphasize this and make it really count in the painting, as in *Squash* (right). Notice too how in this painting, and

French Garden and a Labrador in the Shade
48 x 71 cm (19 x 28 in)
Here, the tonal contrast helps focus the attention on the central area, which is the main topic of interest.

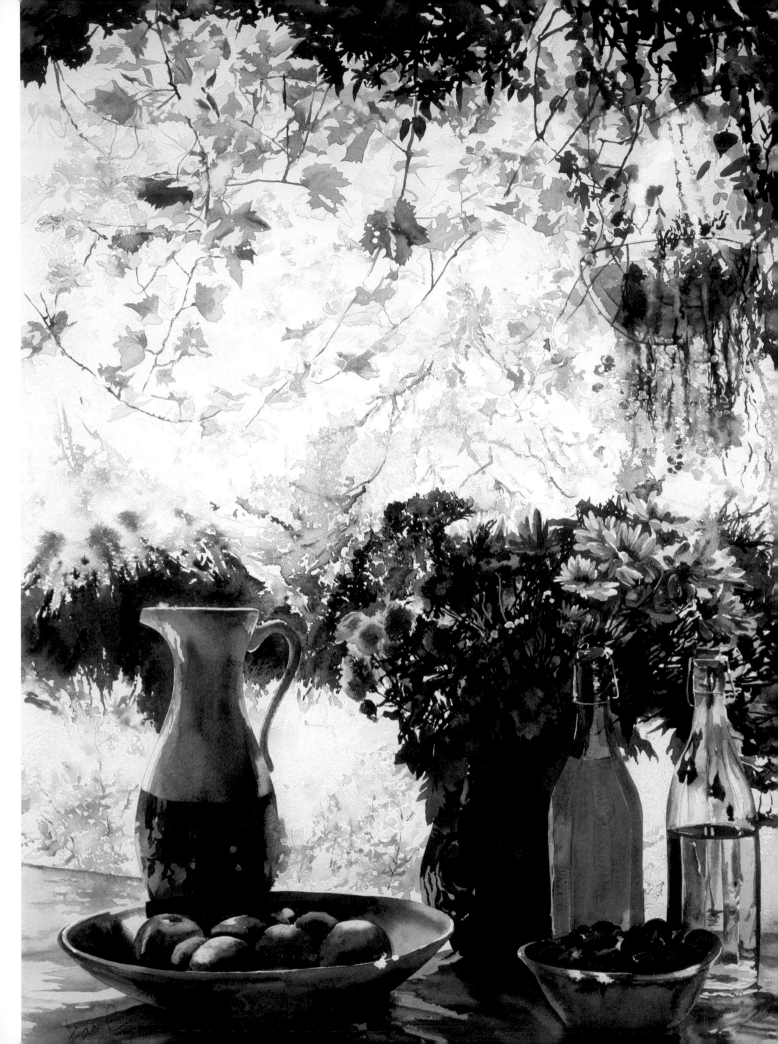

Palm and Cast Shadows
46 x 43 cm (18 x 17 in)
Shadows can add a further interesting element to a subject.

in *French Garden and a Labrador in the Shade* (page 68), the tonal contrast between foreground and background is one of the key factors in creating a convincing sense of space and depth.

Drama and Mood

It is the influence of light, above all other qualities, that imbues a scene with its special mood and atmosphere. Re-creating the mood, so that it is convincing in a painting, is something that usually requires a certain amount of selectivity, imagination and exaggeration. This normally means making the darks stronger and the lights weaker, so that the tonal contrast is intensified and consequently the drama of light, with its associated mood, is more apparent. In fact, it is often the case in painting that if you want to make a particular point and draw the viewer's attention to something, this has to be done with some emphasis.

Night scenes are probably one of the most difficult types of subject matter as far as tonal values are concerned. The main problems are judging the colours in terms of relative dark tones, creating enough variety in the darks, and suggesting a feeling of space, yet not losing the impression that it is night-time. I concentrate on the darks first and then I usually add a few highlights and details with white ink, which creates a vivid contrast and actually enhances the sense of darkness.

I think you have to use your imagination about the colours in a night scene. There will be some light – usually artificial light – although that will probably distort the true colours of things. So there may be an indication of colour in places, but on the whole you have to invent the colours, choosing those that will evoke a feeling of night-time, rather

Nightlife I *(left)*
51 x 41 cm (20 x 16 in)
For night scenes I think you have to use quite a lot of imagination and choose colours that evoke the feeling of night-time, rather than aiming for realism.

than aiming for realism. In my Mediterranean night scenes, as in *Nightlife I* (page 70), I use a lot of dark blues. See also *Irises at Night* (page 60).

Exciting Shadows

I think shadows are fascinating, and I especially like the shapes and pattern effects that they make. Every subject includes shadows of some kind, and these add another interesting element that contributes to the overall mood and impact of a painting. The general character of shadows is determined by the quality and direction of the light as well as being influenced by the different surfaces on which they fall. If the light is even, diffuse, and low key the shadows will be barely discernible, while in the bright, direct Mediterranean sun they make very powerful shapes, and in fact can be the most important part of the subject matter.

In *Palm and Cast Shadows* (page 71), for example, I thought the striped shadows on the wall and balustrade were particularly interesting and effective. Again, in *Ivy Pillar* (right), it was the pattern effect created by the cast shadows that attracted my attention, especially the shadows under the bench, which tell us that the bench is slatted and the ground is slightly uneven. Note that when an object is close to its shadow the edges are sharp and defined. In contrast, when there is some distance between the object and its shadow, as in *Exclusion* (page 74), the shadows are softer and less distinct.

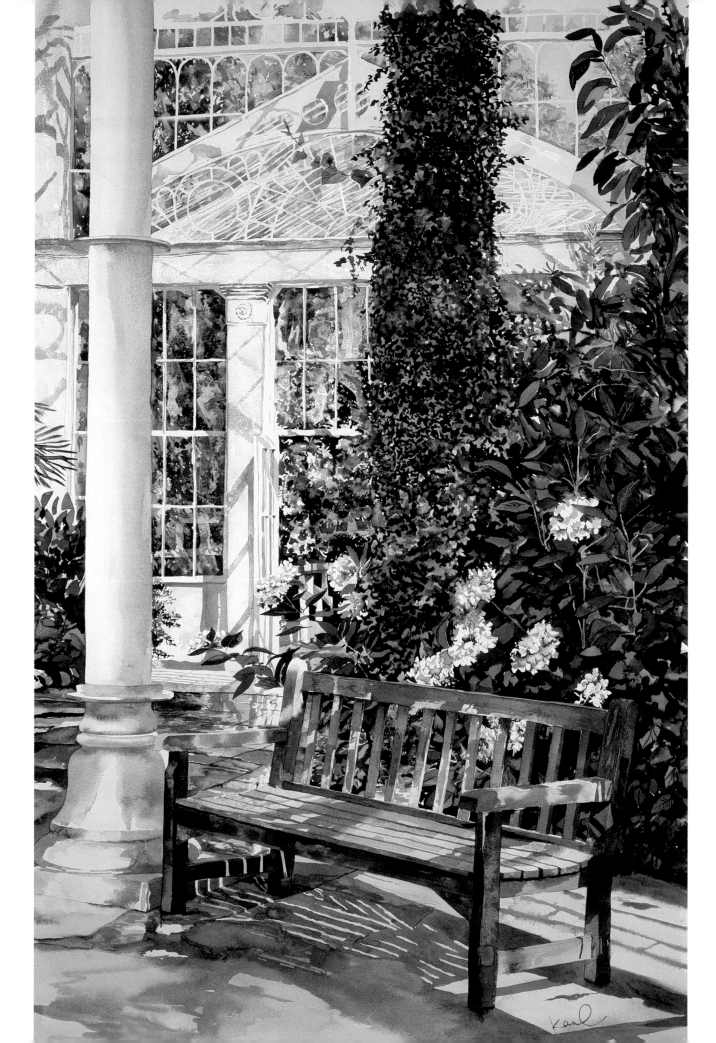

Exclusion
56 x 76 cm (22 x 30 in)
These shadows are a vital part of the
overall design of the painting.

Shadows as a Subject

Sometimes I find ideas in which the shadows themselves play the dominate role, and consequently are the quality that I most want to capture in a subsequent painting. For instance, in *Bamboo Shadows* (above right) it is the shadows that create the greatest interest, and perhaps the more so here because we cannot see the objects that cast them. Similarly, even in paintings where the shadows are not the main feature, they can contribute in a very positive way to the success of the composition.

Foreground shadows can be extremely useful in this respect, enlivening what otherwise might be a fairly dull area and at the same time helping to lead the eye into the painting. In other areas the shape of shadows, and the way that they change tone and direction, can help suggest a sense of depth. These are characteristics that I often exploit, and again sometimes emphasize for effect. With some experience you will find that it is possible to invent or distort shadows to suit your own ideas, yet still make them look convincing. In *Bright Cushions* (right) you can see how I have made good use of the shadows on the table to add interest and to aid the composition.

Bright Cushions (right)
56 x 76 cm (22 x 30 in)
Here, the cast shadows on the table
help to balance the composition.

Bamboo Shadows
Watercolour sketch.

Bamboo Shadows
53 x 71 cm (21 x 28 in)
The shadows of the bamboo
sticks make this row of pots all
the more interesting. I like the
fact that we cannot actually see
what is casting the shadows.

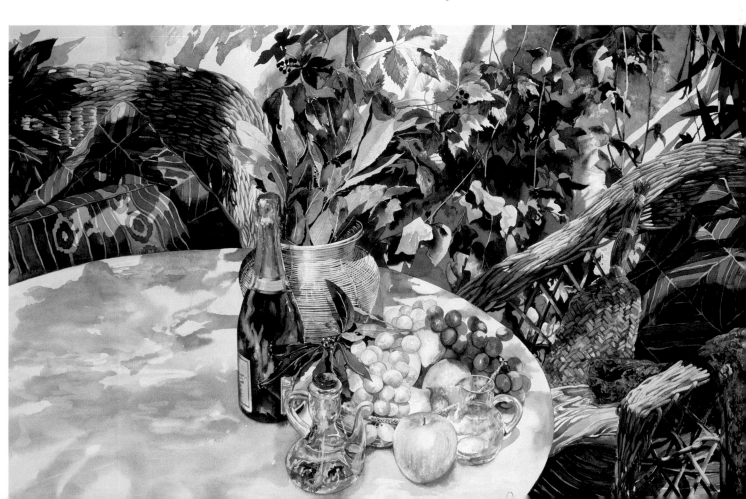

Shadows and Colour

Estimating the colour of shadows, particularly intense, dark shadows, is sometimes very difficult. Shadows are never black, of course, and in fact they are seldom one colour all over – normally they contain a surprising variety of colours. Equally, there are differences in tone, with the darkest part of the shadow nearest the object to which it relates. Consequently,

Window with Bougainvillaea and Blind
81 x 56 cm (32 x 22 in)
The shadows in this painting take on some of the pinkness of the original flowers. This generally happens when an object is close to its shadow and strong in colour, but adding colour to a cast shadow is also a useful device to unify a painting.

there is no single technique for painting shadows. Each one has to be carefully considered, both with regard to what has been observed and in relation to the overall needs of the painting in terms of colour, composition, tone and so on.

Interestingly, in some subjects the truest colours are found in the shadows rather than on the objects themselves. For example, the part of a building seen in bright sunlight will have a bleached colour, whereas the part in shade will be nearer the actual colour. To summarize, the shadow colour is usually a different tint of the colour found on the object casting it, and it often contains some of the complementary colour. Additionally, the colour of a shadow is influenced by the colour of the surface on which the shadow falls.

The main point to bear in mind about shadows, I think, is that they are shapes and colours that are just as important and need just as much attention as any others in the painting. See *Window with Bougainvillaea and Blind* (left) and *Common Brilliance* (below) for examples of paintings in which shadows are a major aspect of the composition.

Common Brilliance
56 x 76 cm (22 x 30 in)
Colours in the shade are often saturated and brilliant – for example the orange of the door here. In contrast, note how the part of the door in sunlight appears bleached in colour.

4 | A Personal Response

It is always interesting to see how different artists respond to the same subject matter. For although there may be similarities in the way that each artist approaches a given subject, inevitably the final paintings will show a certain degree of individuality. If a group of artists is painting the same landscape view, for example, the likelihood is that each of the finished works will have a different emphasis and impact. Possibly in all the paintings the general features and character of the landscape will be recognizable, and it may be quite easy to identify the specific location, but somehow each artist will perceive and express what is there in a very personal and distinctive way.

I believe this is how it should be: painting is essentially concerned with individual interpretation and expression. In my paintings I am very interested in colour. Usually I exaggerate the colour qualities and relationships found in a subject, in contrast to other aspects, which I might well leave understated. For me, colour is invariably the most exciting, inspirational element, and it is primarily through the power of colour that I like to convey my thoughts and ideas. Other artists find that their motivation and interests stem from something quite different. The main point, I think, is to be true to yourself and respond to your own ideas and feelings about the subjects that you choose to paint.

So, even for those artists such as myself who work in a representational style, a successful painting isn't necessarily one that aims simply to capture a true likeness of what is there. More important is that it evokes a certain mood or sense of place and that it shows some originality in concept and technique. Therefore you should not be afraid of focusing on what you think is the most interesting aspect of a subject, nor should you be half-hearted about expressing this in your own style.

Subject Matter

I love the special qualities of light, colour and texture that for me are synonymous with the Mediterranean region, and almost without

The Lights Go On
52 x 74 cm (20½ x 29 in)
This was a subject that I simply could not resist, as it combined two of my favourite themes – buildings on a hillside and night-time lighting. Essentially the reference information came from a photograph, although the painting also involved a certain amount of invention.

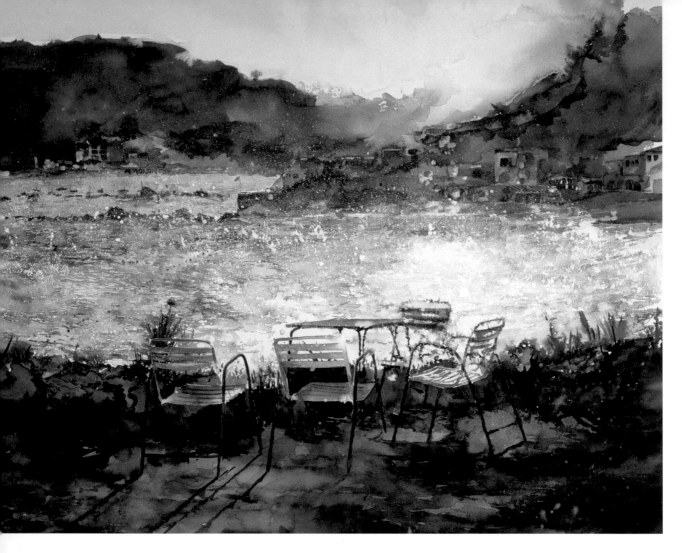

Sea Beads
53 x 66 cm (21 x 26 in)
As here, I like scenes that suggest a human presence without actually including specific figures. The group of chairs around the table creates an interesting focal point.

exception my paintings are inspired by the rich variety of images that can be found there. I am particularly interested in subjects such as hill villages; the sea and boats; intimate landscape scenes; balconies, doorways, shuttered windows and other architectural details; and invitingly placed tables and chairs, perhaps set out on a shady terrace or patio.

I seldom paint figures, although often my choice of subject matter implies a human connection or presence. *In The Lemon Tree* (right), for example, I like the fact that the chair is unoccupied. It allows viewers to connect with the painting in a much more personal way – to imagine what it would be like to sit in the chair themselves, enjoying the warmth and tranquillity of the scene. Similarly, in *Sea Beads* (above), the chairs and table help to attract the viewer into the painting and at the same time form a pleasing focal point.

The scope for subject matter is infinite, and of course different subjects will appeal to different artists. Remember that an idea does not have to be obviously intricate and colourful to work as a successful watercolour. Sometimes just a single object will make an attractive, interesting painting, especially if it is expressed with some verve and spontaneity, as in *Greek White Again* (page 113). But whatever the subject matter is should excite you and invoke a strong desire to paint it.

A variety of subject matter and approaches is important, I think. I like to chop and change from one subject to another, and I also work in different media – mostly in watercolour, but sometimes in oils or

acrylics. Equally, I will vary my watercolour technique. Depending on the subject matter I may decide to work in a quite controlled way, or I may paint very freely, or sometimes I combine both methods. Variety helps to keep the work lively and encourages development. In my view there is little point in repeating ideas, or only painting subjects that are guaranteed to succeed. That is not the best way to improve.

Inspiring Qualities

After travelling to the Mediterranean for many years I know the main areas of Italy, Greece, Spain and the South of France where I am likely to find the sort of subjects that will appeal to me. Generally, as I have mentioned, these are subjects in which light and colour are qualities that play a dominant role in creating an image that has interest and impact. For example, it was the contrast between twilight and artificial light that inspired me when I came across the village scene shown in the painting *The Lights Go On* (page 78). Gradually, all the windows in the intriguing hillside village sparkled in the growing darkness. Often it is a certain

The Lemon Tree
66 x 56 cm (26 x 22 in)
The scope for the subject matter is tremendous, so act on your instinct. If, for whatever reason, something strikes you as interesting, it will probably make a good painting.

Swinging Doors, Shocking Walls
47 x 58 cm (18½ x 23 in)
Brightly coloured Mediterranean walls, especially if lit in a dramatic way, offer plenty of scope for interesting paintings.

aspect of light, mood, colour or texture that first attracts me to a subject, rather than its intrinsic shapes and forms.

As far as choosing subjects is concerned, my advice is to act on your instinct. If, for whatever reason, something strikes you as interesting, then it will probably make a successful painting. Better this approach, I think, than having preconceived notions about what makes a good painting – for there is no magic formula. When I arrive at a location I like to spend time just wandering around – not looking for particular subjects, but certainly ensuring that any promising ideas are quickly recorded in some way, either as photographs, sketches or notes. My aim is to collect a wealth of reference material that will provide useful ideas and starting points when I get back to the studio.

Ideas and Style

It is easy to identify the work of established artists because they have a recognizable style. They use colour and apply paint in a very distinctive, individual way. However, artists generally do not set out to create a certain style; it evolves over a period of time. And even then a style is never quite fixed, for subtle changes can occur as an artist acquires greater skills and experience. Your style will reflect your interests and capabilities, and no doubt it will incorporate influences from various other sources. Try not to be too conscious of style, but rather let it grow naturally. As you pursue certain subjects, develop particular techniques and paint with increasing freedom and confidence, so your style will gradually emerge.

There will be some artists whose watercolours you greatly admire, and possibly you will want to emulate their style. There can be value in this: in fact, when I first became interested in watercolour painting I tried copying a number of different styles. Although someone else's style can never be your own, you can learn from it and maybe assimilate some aspects of it into your own method of working.

As your painting technique develops, so you will realize that there is a correlation between subject matter and style. While there may be quite a

range of things that you like to paint and that eminently suit your style, equally you have to be aware that there are some subjects that simply will not work for you. In selecting a subject, therefore, you need to make a broad assessment as to how you want to interpret it and consequently whether it is appropriate to your style of painting. Similarly, you have to consider the strengths and limitations of the watercolour medium itself, and how well your intentions for the subject matter can be expressed using this medium.

Observation

Many artists agree that one of the most important skills to develop is the ability to observe, so that you can make quick decisions about the suitability of subject matter and related aspects of painting. When I am out on location and I notice something interesting, instinctively I start

Pots before the Storm,
Beside the Sea
71 x 53 cm (28 x 21 in)
I have used a combination of loose painting and more controlled areas in this work, which was composed from a combination of photographic reference, visual memory and imagination.

A Personal Response 83

evaluating it and, if I think it is a potentially good idea for a painting, I immediately take a photograph or make a sketch. But we need time to acquire such skills and instincts, and indeed they will only develop if we are prepared to encourage them by looking, drawing and generally using our powers of perception and visual awareness.

Although now I no longer do a lot of sketching and drawing as a process in its own right – I prefer to devote as much of my time as possible to painting – I would nevertheless strongly recommend drawing from observation as one of the best ways to develop skills in looking and understanding. Through drawing, we learn to notice things and be selective, which in turn enables us to focus on those qualities in a subject that make it individual and interesting. Gradually, this process of looking and evaluating becomes second nature until, if we wish, we are able to make important judgements about subject matter without necessarily starting with a drawing.

Recording Ideas

Rocking the Boat
47 x 71 cm (18½ x 28 in)
I seldom spend a great deal of time assessing a subject from different viewpoints and so on. Rather, I look for subjects that have an instant appeal, and I like to respond to that in the painting.

As I did for *Rocking the Boat* (below), I normally use photographs to give me some form of reference or starting point for my paintings. Essentially, I rely on photographs because they are a very quick method of gathering lots of information when I am travelling abroad. But, as explained in the section on Reference Material in the next chapter (page 97), I never make a painting simply by copying a photograph. Rather, the photograph provides an *aide-mémoire* for the composition or subject matter.

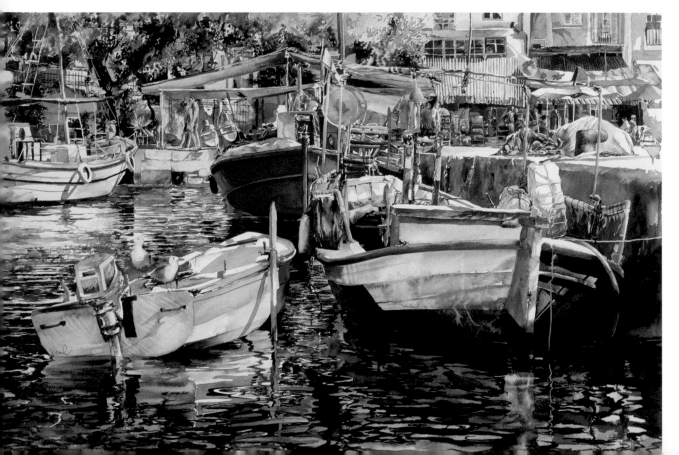

Break in the Clouds
10 x 7.5 cm (4 x 3 in)
Variety is good for your work, I think.
As well as the controlled approach
that I use for my detailed paintings,
I also enjoy working in a much freer
way, as here.

I would suggest that if you do not have much experience in drawing and sketching – and therefore your skill at judging relative scale, colour relationships and so on is limited – then you should not rely too much on photographic reference to begin with. It is important to develop a certain level of drawing skills, as these inevitably will be useful in creating watercolours, particularly in the design and structure of a painting. Only from this initial experience can you appreciate how best to work from photographs, and what sort of dangers they hold for the uninitiated.

Although I seldom now do any sketching in the street, I often make some drawings at the villa or house where I am staying. I also occasionally refer to books and magazines for particular details and information if needs be. Sometimes, good-quality photographs in a magazine can provide a useful guide for a certain lighting effect, for example.

Visual Memory

Because I am always very conscious of the fact that I am creating a painting, rather than reproducing an image from a photograph or some other source, my priority is to respond to the needs of the watercolour as these arise. This is an instinctive thing: the painting has to look and feel right. Often, in establishing an overall effect that I am happy with, I will enhance the colour, exaggerate certain aspects of the composition, move things around, introduce other shapes, and so on. The final painting is normally a combination of fact and invention. Sometimes, as in *Break in*

the Clouds (page 85), I may glance at a reference photograph, but then paint in a very free and imaginative way.

To paint convincingly it is always a help if you can rely to some extent on your visual memory. Again, this is something that gradually develops over a period of time, based on your growing experience of observing, sketching and painting. When you can inform your studio paintings with the vivid recollection of what it was like to be at a certain place and sense the atmosphere, quality of light, colour and other aspects, then they will be all the more sensitive and evocative as a result.

Essential Elements

The most successful paintings are likely to be those for which you have immense enthusiasm – where you are painting because you feel a real need and desire to express a particular idea or represent a subject that has greatly impressed you. However, inspiration and motivation alone are

Lazy Lunch
52 x 74 cm (20 x 29 in)
When I saw this meal set out in the garden where we were staying in Andalusia I thought it would make a good subject for a painting, and so I took some photographs for reference. The painting is very evocative of that kind of holiday experience, I think.

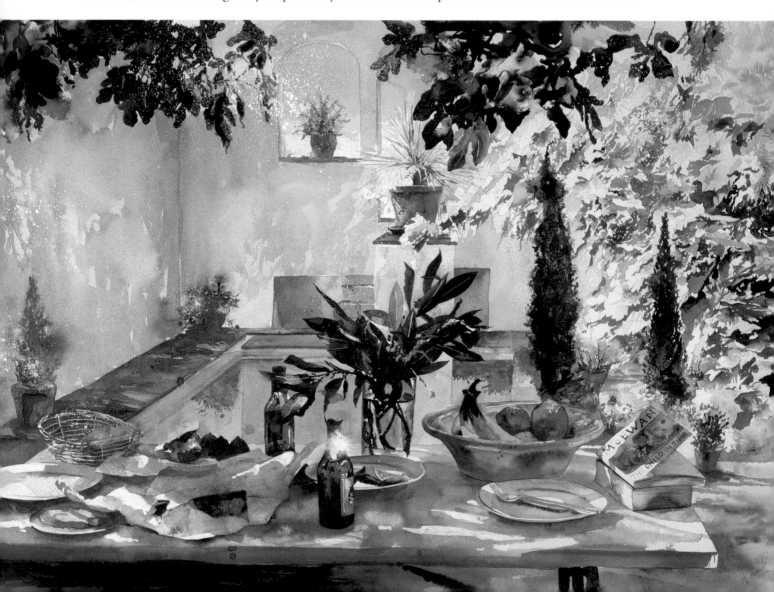

Small Mediterranean Buildings
15 x 20 cm (6 x 8 in)
Here the focus is on the ambiguous Mediterranean blue – it could be the sea or the sky.

not sufficient to ensure the best results, and indeed sometimes the eagerness to get started on an idea can lead to disappointment if the general concept and direction for the painting have not been adequately thought through.

Personally, I now do very little in the way of what might be termed 'planning'. But, especially with the more complex subjects, I like to be clear in my mind as to my intentions for the work and roughly how I aim to achieve them. The photographs that I use as starting points will usually give me all the information I need. If, however, I decide to move shapes around or combine elements from different photographs, then I will make some small, simple drawings in my sketchbook to help me define the composition before I begin painting.

You may find that you require far more preparatory work than this. Additionally, some artists like to make an initial tonal sketch, or they find it helpful to have one or two colour studies or drawings of the principal objects and details. For specific information on preliminary studies and other reference material, the sort of techniques you can use, and how to develop your sketches to the best advantage, see Reference Material (page 97).

Of course there must be a happy balance between preparing for a painting so that you can tackle it with the right degree of freedom and confidence, and exhausting what you want to say about the idea before you start. Paintings that result from a totally prescribed approach usually lack vigour, and while technically they might seem very successful they somehow fail to excite and impress. The best approach is one in which there is a clear objective but at the same time sensitivity to ideas and effects that may evolve as the painting develops. In watercolour especially, because it can be such an unpredictable medium when used expressively, there will be 'happy accidents', and the wise artist will exploit these.

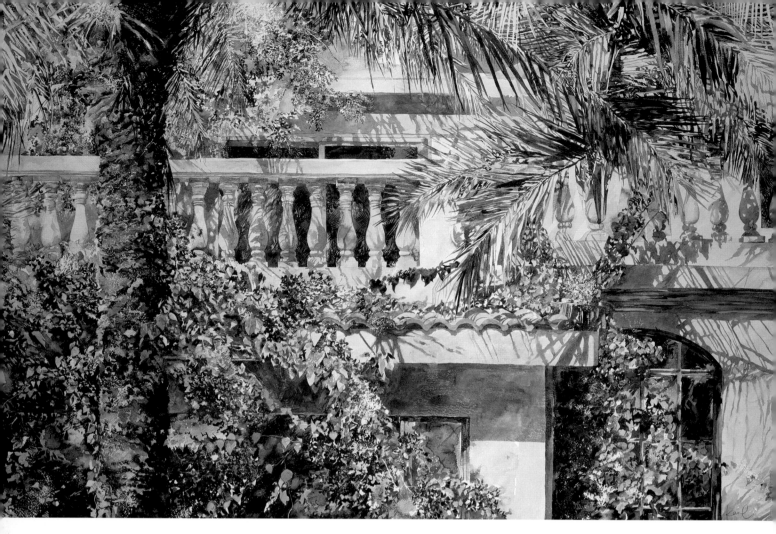

Practical Considerations

Whatever the subject, and the type and amount of preparation you do, it is unlikely that you will just want to make a straightforward copy of the subject as you find it. Probably you will have your own idea as to which aspects of the subject are the most significant, and consequently where you would like to make some kind of emphasis and focus. Notice how in *Shadow Mad* (above), for example, I was not that concerned with the appearance of the building as a whole, or the windows. Instead, the focus is on the shapes of the balustrades, which are sharply contrasted with the dark background and the shapes of the palm tree fronds and their shadows.

There are also important practical issues to consider when planning a painting, such as its shape and size, and the most suitable type of paper to use. As well, you may need to stretch the paper (as described on page 20). Do not feel obliged to keep to standard-size sheets of paper if a square or elongated format will work better for the subject matter and its impact. And try not to be intimidated by the price of watercolour paper and the possibility that you might make a mistake or two! In fact it can be fun to work on a big scale, although equally it requires some courage. I once did a whole series of paintings on 101.5 x 127 cm (40 x 60 in) sheets of paper, which cost £25 per sheet! As explained on page 107, if a painting is not totally successful you can salvage the best part by cropping it (trimming the painting to a smaller size).

Composition

Some subjects need very little modification to their basic content and design in order to work as effective paintings. They can be taken as found, for essentially the main shapes create a composition that is both interesting and successful in terms of holding the viewer's attention and enabling them to 'read' and understand the content. With other subject matter it is necessary to think far more carefully about the composition and, perhaps, how it can be improved or adjusted somehow to better serve your aims for the painting.

Essentially, composition relates to the way that the various shapes found in the subject matter are arranged within the picture area. The main elements of composition are line, mass, tone and colour. It is how you use these elements – the balance, contrasts and relationships that you create between them – that is so influential in determining the

Two Straw Hats
53 x 74 cm (21 x 29 in)
Although it is supposed to be something to avoid, putting your focal point (the white chair) in the centre can be successful if the balance of the rest of the painting is right.

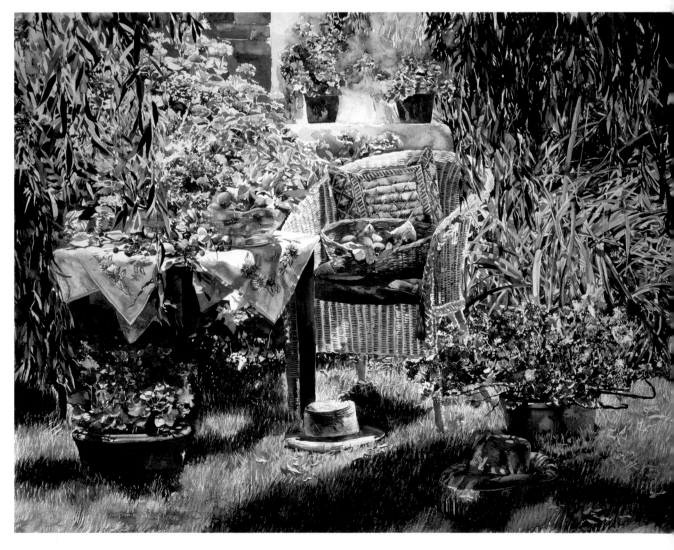

character and impact of a painting. In practice, decisions on the arrangement of different shapes and colours, and their relative importance, are a matter of interpretation. Normally it is necessary to emphasize some, and to simplify or ignore others.

Theories and Instinct

So, how can you judge whether or not a painting is well composed? This is always a matter of personal opinion of course, although there are some general factors that will apply. For instance, the aim is to maintain the viewer's interest in the picture, and therefore the composition must be so devised that there is some drama in it (with the colour, the way that the content is presented, or both), and equally that the flow and dynamics of the design help the eye travel around the painting, but stay within its bounds.

Kensington Gardens
46 x 51 cm (18 x 20 in)
Here, because the foreground is in shadow, we are encouraged to look into the lighter, background area.

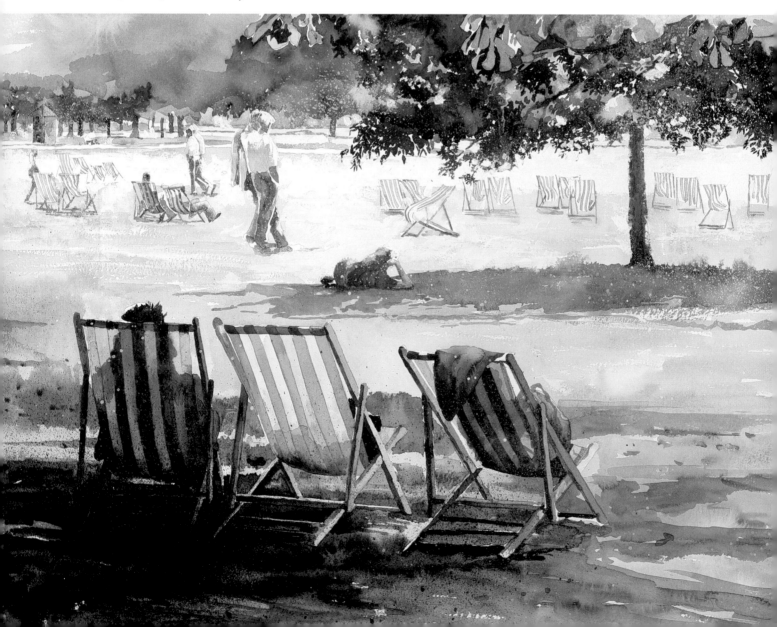

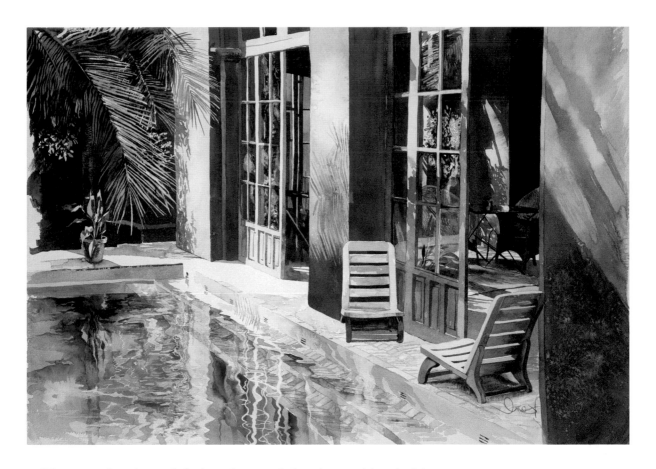

Carmona Pool
38 x 51 cm (15 x 20 in)
The composition in this painting is devised from counteracting diagonal and vertical lines.

There are theories and devices that can help when making decisions about the composition, and these are worth knowing and considering to begin with. But a composition that depends solely on theories will look very contrived, so I mostly rely on my instinct to tell me whether or not something looks and feels as though it is in the right place. Perhaps the most useful theory is the one relating to the Golden Section (the dividing point in a picture where the smaller section is in the same proportion to the larger section as the larger is to the whole), which artists tend to think of in approximate terms as a division of the picture surface into thirds. Indeed, a composition that always seems to work well is one in which the principal feature, focal point or area of greatest interest is placed about one-third (or two-thirds) of the distance across the painting – either horizontally or vertically.

Most art teachers would advise against having a composition that is symmetrical or evenly balanced, although in fact this can work very effectively if you have the confidence to try it. Designs that exploit a diagonal or triangular division also work well, as do those based on 'S' or 'Z' formats, which use snaking lines or shapes to lead the eye from the foreground of the painting into and around the subject.

The composition in *Carmona Pool* (above), with its strong diagonal and the building shown in perspective, is an unusual one for me. You

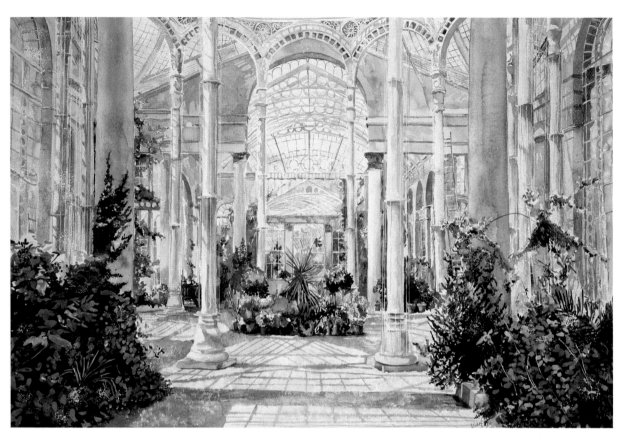

Symmetry and Nature at Syon
43 x 66 cm (17 x 26 in)
My own preference is for very symmetrical designs, such as this.

can see that this particular design is loosely based on dividing the paper in thirds, and notice too how the shadows and reflections play a part in linking different areas of the composition. More typical of the type of composition I like is that shown in *Symmetry and Nature at Syon* (above). This is a very symmetrical design, with strong verticals and horizontals. In a sense it breaks all the 'rules' because it is so balanced and has the main area of interest right in the centre of the picture. Nevertheless, I think it works well and makes an interesting painting.

Creating Impact

Another quality that I like in a composition is the sense that, when viewing it, you are discovering points of interest rather than feeling that everything has been deliberately arranged for you. This effect, of creating an element of surprise and drama, can be achieved by placing objects and details right on the edge of a painting, for example. In any case, I am never conscious of designing around a focal point, although naturally there are some parts of the subject matter that interest me more than others and therefore attract a more thorough treatment.

Impact is also created through contrast – there can be contrasts in colour and tone, in shapes and forms, in detail and simplicity, and in painting techniques. Generally I would say that, to successfully convey

what you have in mind for a subject, and support this by means of an effective composition, you need to overstate things to a certain extent. If something is red, make it really red; if you are painting a lemon, make it more lemon-like than it actually looks!

The composition in *Lela's* (page 94) is layered from foreground to distance – objects, table, plant, wall, sea and distant hills – and this creates a different kind of impact, through the changes of scale and detail. In contrast, in *Glass and Asters* (page 95) there is a uniformity of colour, tone and shape, giving the painting a flat, tapestry-like appearance. So, whatever the balance between careful planning and instinct, the composition is always important, and there are all sorts of ways of making it exciting and effective.

Plants on the Edge of Town
38 x 51 cm (15 x 20 in)
There are similar tonal values throughout the background area in this painting, creating a flat, pattern effect.

Glass and Asters (left)
58.5 x 38 cm (23 x 15 in)
Here, the whole surface of the
painting is treated with the same
degree of interest and detail,
giving a tapestry-like appearance.

Lela's (opposite)
74 x 56 cm (29 x 22 in)
This is what I would term a layered
composition, with distinct sections
for foreground, middle ground
and distance.

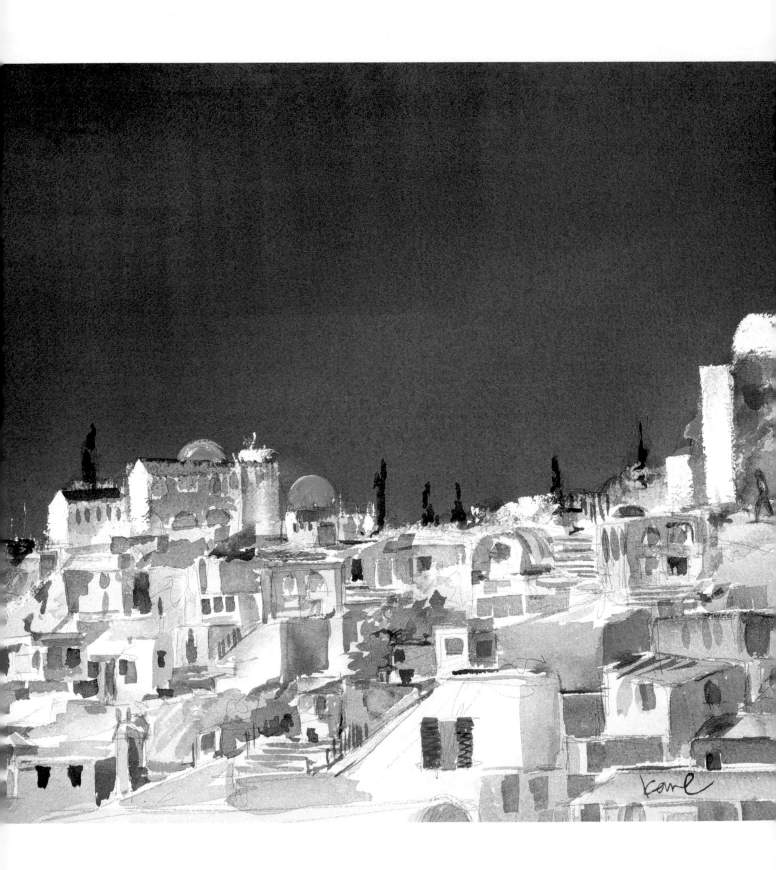

5 | Freedom and Control

Interestingly, the two principal ways that I like to work are both quite extreme. For most of my watercolours I use a very controlled technique, which allows me to concentrate on small areas at a time and thus gradually build up the design and overall impact of colour and pattern that I find so fascinating. However, in contrast, when I feel in a confident, experimental mood I greatly enjoy painting in a much freer, spontaneous way, sometimes in fact working entirely from imagination.

Neither of these methods suits painting on location, so all my watercolours are made in the studio. With the controlled approach I often work on a large scale and, of course, each painting takes a fair amount of time. Such work would not be possible outside, where, due to changing light, weather and other circumstances, time is limited. Similarly, with the fast-and-loose approach, although the paintings are smaller, I do need the full range of my equipment and materials available, and therefore I must be in the studio.

In fact, a lot of my work is what I would term illustrative rather than fine art, and because of this I need time to plan and consider what I am doing. This is another reason why I do not paint on the spot. I think you have to be true to yourself and paint in the way that you feel most comfortable with. Some artists are very happy working from direct observation and they have the skill and speed to do this successfully. But whichever approach most interests you – and maybe it is a combination of both studio and location work – I hope you will find some helpful points from the description of my working methods, which I will now explain in further detail.

Reference Material

When you work in the studio you will need some kind of reference material to help you plan and complete your painting in a satisfactory way. You can gather useful material in the form of sketches, notes and quick watercolour studies; as photographs; or by using a combination of

Greek Man
48 x 45.6 cm (19 x 18 in)
Rough paper is best for freely expressed paintings and those in which texture is important.

both methods. Drawings and written or visual notes in a sketchbook can be made with a variety of media. My advice is to choose a medium that will give you quick results and that you feel confident using. For example, charcoal is good for fast, tonal sketches, while water-soluble coloured pencils offer a versatile approach for colour work.

In a sense, the actual method you use to record ideas is immaterial. Moreover, the sketches do not have to be highly detailed, finished drawings, nor do the photographs have to be well composed and perfectly focused. What is essential about the reference material is that it records something of the particular feature or quality that initially attracted you to the subject, and therefore will subsequently help you express that quality in the final painting. In fact, many artists develop their own distinctive 'shorthand' sketching method for jotting down such information – sketches that may not mean much to anyone else, but are a very effective *aide-mémoire* for the artist.

I do think it is necessary to acquire certain basic skills regarding observation and sketching, but once you are confident about these then I think it is perfectly justifiable to rely mainly on photography, which is the approach I now use. I occasionally make sketches to plan ideas, and now and again I do some drawing. But for me, drawing is an activity in its own right, rather than something to do in preparation for a painting. One of the advantages of photography is that you can gather an enormous amount of information in a relatively short period – which gives you more time to spend on the paintings!

Photographs

I have made various references to photographs in other parts of the book, but I think it worth mentioning some additional important points here. As I have said, high quality in the photographs you take for reference purposes is not essential. However, I would go further than that and say the qualities that contribute to a good photograph are by no means the same as those that will make a successful painting. The two are quite different art forms. I have many excellent photographs that I have not used as a reference for paintings because I know that such paintings would not work. Good photographs have a different kind of visual punch to that which you would aim to develop in a painting.

So you have to think carefully about how a photograph will translate into a painting. The other important point to remember is that it is a mistake to copy exactly what you see in a photograph. Change it, add ideas of your own, and leave something to discover in the painting. The final painting will be much more interesting and exciting if it is not simply an enlarged version of the photograph. Remember too that you are using watercolour, and so the medium itself should be allowed to impose its own character on the work.

The Controlled Method

For the majority of my paintings I like to work in a fairly detailed manner, and with as much control as the medium will allow. Consequently the design of each painting is normally quite complex, with an equal degree of emphasis and interest across the whole picture area. The advantage of this is that it is possible to complete the painting by focusing on each small section in turn. It also means that I do not have to use large washes of colour. Instead, I start with more controlled, confined patches of colour and subsequently develop the necessary detail, moving from one area to the next. Gradually the various parts fit together in a sort of jig-saw fashion to form the complete, coherent design.

This process is demonstrated on pages 99 to 100 with the painting *Granada*. As here, I normally have one or more photographs as reference, and I may decide to make a preliminary sketch in my sketchbook to get a feeling for the idea and the composition that I want. For this painting, in order to make the composition read more clearly, I decided to change quite a lot of the foreground that is shown in the photograph.

Granada was painted on Not-surface paper, which is the paper I normally choose for the controlled technique. I began with a faint pencil drawing to define the main shapes, then I blocked in the basic

Granada (below, left)
Reference photograph.

Granada (below, centre)
Sketchbook study.

Stage 1 *Granada* (below, right)
I always start with the light colours, and then I let this stage of the painting dry.

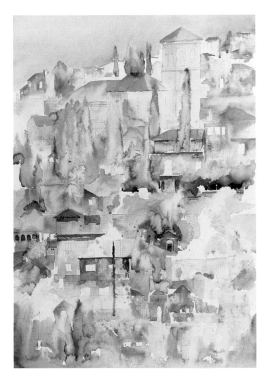

bright and light colours, as shown in stage 1 (page 99). I always start with the light colours because it is easier to keep them pure and transparent at this stage, while the palette and water are fresh and clean. The way I usually work is to mix a quantity of a particular colour and apply that to all the appropriate areas, before thoroughly rinsing the brush and starting with the next colour. I let the initial work dry, then, as shown in stage 2 (below), I reconsider each area of the painting and decide where I will add shadows, details and so on.

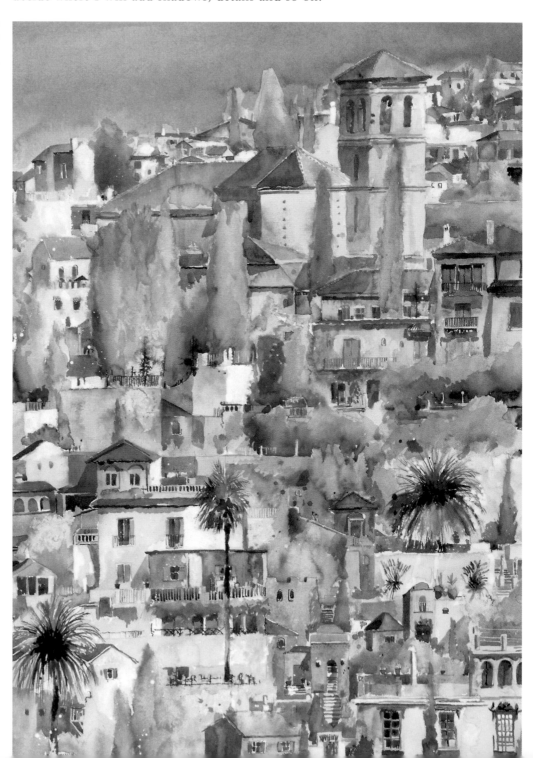

*Stage 2 **Granada***
56 x 76 cm (22 x 30 in)
Now I consider each area in turn, adding the necessary detail, shadows and other effects.

Combining Techniques

In contrast to *Granada*, in which the colours are mostly applied wet-on-dry or wet-against-wet, many of my large, controlled watercolours also involve quite a range of other techniques, including the use of masking fluid, spraying and various texture effects. The way I incorporate such techniques successfully within a painting is demonstrated in *Pots on the Wall*, stages 1 to 8 (pages 101–103).

You will notice that I started with a quick watercolour sketch as a means of familiarizing myself with the subject matter and deciding which techniques I might use. Again, the final painting was made on Not-surface paper, and as usual I began with a careful drawing of the main shapes.

The first areas I worked on in watercolour were the flowers and leaves. For most of these areas, having applied the red of the flowers, I then sprayed the colour with water (using the small spray bottle) to create a slightly diffused effect (stages 2 and 3, page 102). Then, while the surrounding area of the paper was still damp, I added the green for the leaves. Sometimes, if I want a more exaggerated, less controlled diffused effect, I spray the paper first and then apply the colour.

For the pots, whose cylindrical, three-dimensional forms are enhanced by the light effect, I have used a blending technique. I painted the dark side of each pot first (stage 4, page 102). Then, after quickly rinsing and partially drying the brush, I worked from the edge of the existing colour and pulled some of the paint across the rest of the pot shape. As can be seen in stage 5 (page 102), I also blotted the light side with some tissue paper to give it a slightly mottled texture and a better blended effect. Finally I added some more dark colour, slightly in from the right-hand edge, which was where the most intense shadow occurred.

This painting includes two other techniques that I often use for specific texture effects: salt and masking fluid. As with all techniques, I

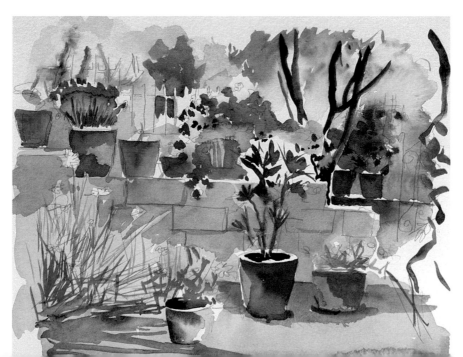

*Stage 1 **Pots on the Wall***
Watercolour sketch.

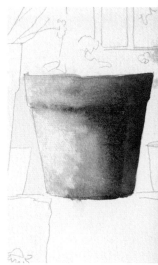

Stage 2 **Pots on the Wall**
*For this painting I started by
dropping some red paint onto the
paper for the flower shapes, which I
then sprayed with some clean water
to create a slightly diffused effect.*

Stage 3 **Pots on the Wall**
*While the paper was still damp
I added parts of the foliage,
wet-against-wet, allowing the
colours to bleed and run together.*

Stage 4 **Pots on the Wall**
*For the flower pots I started with
the dark, shadow side.*

Stage 5 **Pots on the Wall**
*To complete each pot shape I used
a damp brush to pull some of the
existing colour across, then I
blotted the light side with some
paper tissues.*

think these are more effective if they are applied only where they are
appropriate – in a fairly localized manner, rather than throughout the
painting. Therefore, I have used the salt technique on some, but not all of
the bricks, and the masking fluid for only some of the stems and grasses.

The process for the salt technique (stage 6, below), is essentially as
described previously on page 34. However, in this painting I blotted the
wet paint with some paper tissues before sprinkling on the salt, giving a
more varied texture effect. The masking fluid (stage 7, below) was applied
with a dip pen, which I find more controllable and also much easier to
clean after use. Some of the lines were drawn on white paper, some across
existing brushmarks. Additionally, I have used white ink for various
flowers and stems, and it was flicked across some of the foliage in the
background to add a few highlights. Also in the background, the railings
were left as reserved whites, and the tree stems were lightly sprayed with
water while the paint was still wet, to give them a less defined quality.

With all the different techniques in place, I tackled the shadows, such
as those belonging to the foreground pots (stage 8, page 103). I also
added a few touches here and there to ensure that the composition was
unified and had the impact I wanted.

Stage 6 **Pots on the Wall**
*For this type of texture I dropped
some salt into the wet paint.*

Stage 7 **Pots on the Wall**
*I blocked out some of the finer lines
with masking fluid, which was applied
with a dip pen.*

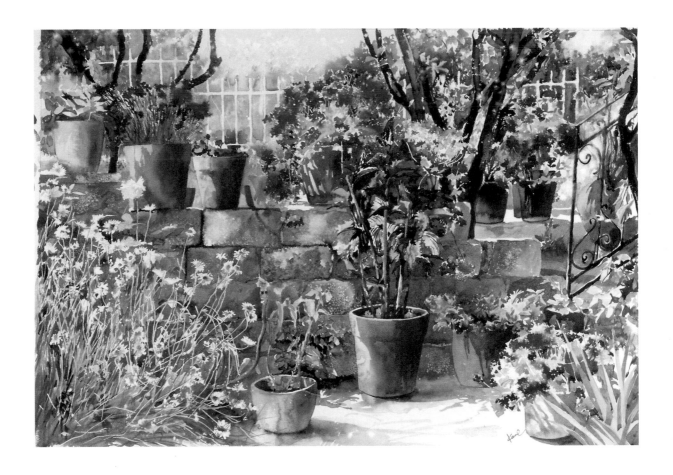

Working Fast and Loose

When I began painting in watercolour I relied entirely on developing a controlled method, and it was some years before I felt confident enough to experiment with an alternative approach. On reflection, I feel sure that was a good way to start, because it meant that I had acquired a sound knowledge and experience of all the main techniques and I was quite familiar with the potential and handling characteristics of watercolour in different situations. This is what is required, I think, before you can begin to adapt the basics successfully to suit your own ideas and create your own style.

However, as I have implied, I do think that you have to be in the right frame of mind to paint well, and certainly to work fast and loose you need to feel confident and playful. For instance, I have days when I enjoy working in a quick, expressive way, but at other times I prefer to tackle subjects in more detail and with far greater control over colour and different effects. *Italian Buildings* is an example of my free, spontaneous approach to watercolour, and you can see how this type of painting evolves by looking at the four illustrations on pages 104–105.

*Stage 8 **Pots on the Wall***
51 x 74 cm (20 x 29 in)
Each technique suits a particular purpose and in the final painting everything comes together to create a unified and interesting composition.

Responding Intuitively

The basic idea for *Italian Buildings* came from the photograph shown above, but as you can see in the sequence of paintings, I have made rather more of the foreground tree, while the colours and various other aspects are radically different. Especially with the expressive approach, I regard the photograph only as a starting point, and in fact I often work entirely from imagination. For this particular painting, as shown in stage 1 (above), I started by drawing with a pen directly onto the watercolour paper to indicate the main shapes. I sometimes use inks for the initial drawing, but here I have chosen liquid watercolours, which behave in a very similar way to inks. Brands of liquid watercolours for application by pen, such as Dr. Ph. Martin's, are sold in small bottles and are available from art shops.

The paper I chose for *Italian Buildings* was a heavy quality, Rough-surface paper, and this was sprayed with water (one overall blast from a big spray bottle) before I began work. As a result, the drawing was slightly blurred, which was the effect I wanted. Then I let the drawing dry before starting to block in the general areas with a large mop brush, working wet-against-wet and mixing the colours as I needed them (stage 2, opposite).

From then on the process was quick and intuitive. In stage 3 (opposite) you can see that I have completed the main shapes and added some more intense colour here and there – mainly orange, which has been flicked on. At this stage, as well as the mop, I used a slightly smaller, round brush, which gave a better point and therefore more control with some of the marks. Finally, in stage 4 (right) I enriched the sky area and sprayed on some white ink. I like the fact that I can work in

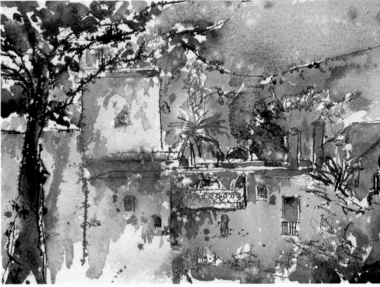

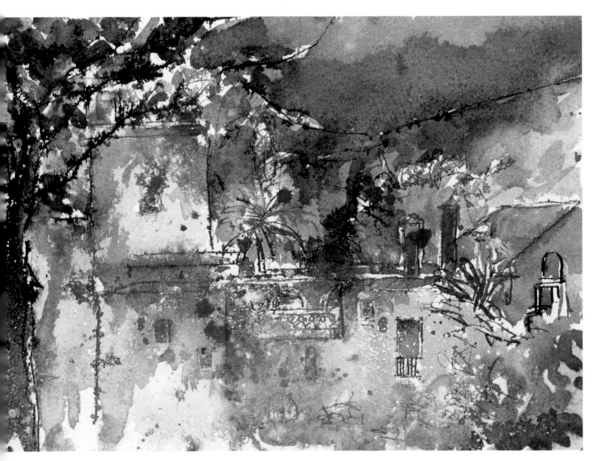

Italian Buildings (far, left)
Reference photograph, which
has gathered a few paint
stains in use.

Stage 1 **Italian Buildings**
(above, left)
*The initial drawing, made in
pen and liquid watercolour.*

Stage 2 **Italian Buildings**
(above)
*Next, I quickly blocked in the
main areas, using a mop brush
and applying the colours
wet-against-wet.*

Stage 3 **Italian Buildings**
(above, right)
*Further colours were added,
including some orange paint,
which was flicked on.*

Stage 4 **Italian Buildings** (left)
*Finally, I enriched the sky
area and sprayed on some
white ink.*

a completely uninhibited way with this type of painting: it is very free and experimental. Success relies on developing an objective eye and learning to recognize what has worked, and when you should stop. Even so, with such a spontaneous method of working, not every picture will be a success – it is largely a matter of deciding whether you want to accept or reject what has happened.

Keeping an Open Mind

No matter which type of working process is chosen, or whatever techniques are involved, it is always beneficial, I think, to keep an open mind as to the exact direction and development of a painting. In my view, even when using a very controlled method, it pays to be sensitive to events that happen in the painting, and to respond to them as necessary. A degree of flexibility undoubtedly helps in achieving the best results. Although it is sensible to plan a painting and have a vision of how you want it to look, I would advise you to regard this as a starting point and a general aim, rather than something that you must rigidly stick to.

Correcting Mistakes

While an accidental dribble may inspire a quite different approach to a certain area, equally it could be disastrous for the effect that you have in mind. So is it possible to make alterations? In fact it is very difficult to correct mistakes in watercolour without damaging the paper or making the mistake more obvious. Fortunately, because of the methods I use, I seldom have to deal with this problem. With my controlled method the

brushmarks are generally quite small and therefore any mistakes can easily be disguised or worked into the surrounding area. And similarly with the expressive method, because of the nature of the different techniques involved and the different artistic result that is aimed at, small mistakes are unlikely to show very much.

When there is something to alter I consider four alternatives: accepting the mistake; blocking it out with some acrylic or body colour; cropping the work (if the mistake is near the edge of the painting and it can be trimmed to a smaller size without destroying its impact); or starting another painting!

I rarely add more paint over a mistake, but if I do, then I somehow try to make it look an intentional part of the work. Because I usually paint with strong colour I never try to 'lift out' areas, which is another technique (explained on page 32) for correcting mistakes. In general my advice is not to worry unduly about minor errors, and certainly not to develop the attitude that anything can be changed if necessary. Rather, you should regard watercolour essentially as a medium that, once applied, should not be altered, because once altered, there is a risk that it will become overworked and lose its freshness and spontaneity.

Bead Curtain
71 x 56 cm (28 x 22 in)
The essential quality of watercolour is its immediacy, creating colour and effects that look fresh and spontaneous. Once applied it should not be altered, because reworking tends to damage the paper and lead to muddy colours.

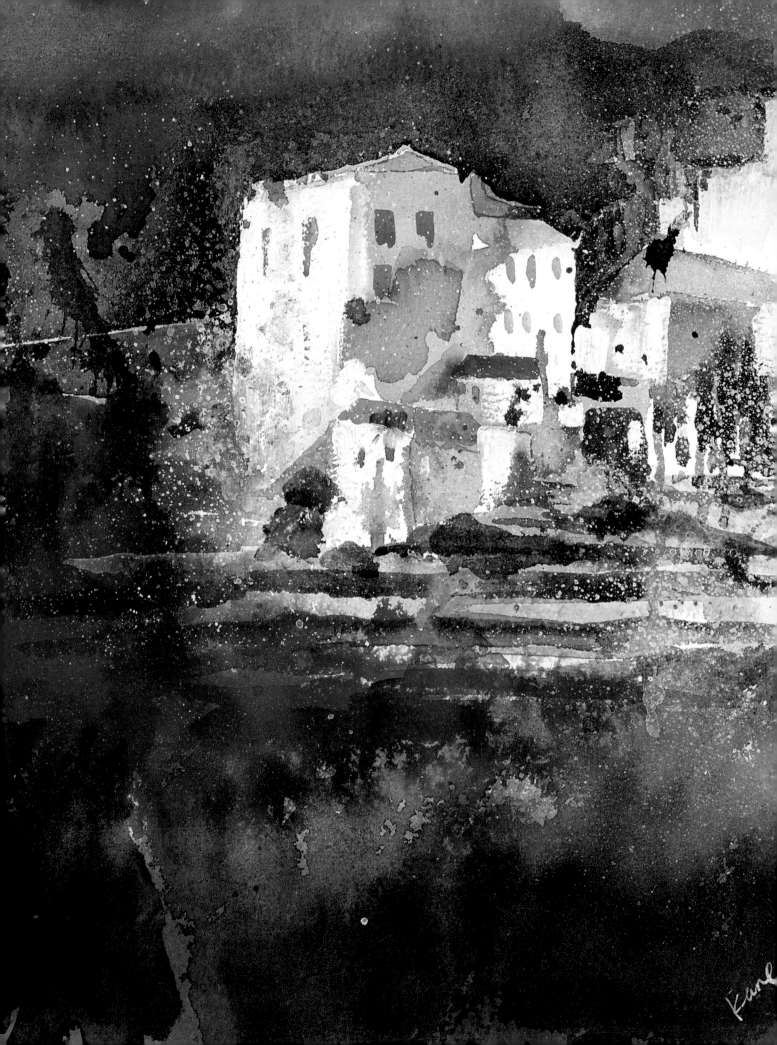

6 | Ideas and Approaches

Skills and techniques are obviously important assets. But equally, successful painting depends on developing an individual way of seeing and interpreting. This is what makes painting so fascinating and gives it such breadth and variety.

Artists can find beauty and inspiration in the most unlikely places. Naturally, therefore, because each artist has his or her own way of responding to the world, and a particular style of working, a subject that inspires one artist will not necessarily impress another. Essentially, what you choose as a subject to paint is influenced by what excites you and how you visualize it in terms of a finished painting. But whatever you prefer to paint, there is no doubt that the scope for subject matter is tremendous.

I enjoy variety. Different subjects and challenges keep my painting fresh and interesting, I think, and help widen my experience and general development as an artist. Most of my ideas for paintings come from subject matter that I have discovered quite by chance while travelling around the Mediterranean and, as I have mentioned, I normally view such material only as a starting point. I may change aspects of the composition, lighting, colour or other elements if I think this will create more impact. My subject matter ranges from still life and flowers to complex views with buildings and colourful, detailed garden scenes.

Still Life

The conventional approach to still life – working from a group of objects that have been carefully selected and arranged in the studio – has a limited appeal for me. With this method I have always felt there is a danger that the paintings will look contrived, and in any case I find this type of painting inhibiting. To be honest, I think sometimes it can be rather boring! Instead, what I most like about still life is the opportunity to explore pattern and colour, and in so doing express something new and different about the subject matter.

Storm and Light
43 x 33 cm (17 x 13 in)
This is one of my more expressive, experimental paintings. Different approaches help keep my painting fresh and interesting, I think.

This said, I have occasionally worked from conventional still-life groups in the past and, despite my reservations about this approach now, I still think it is a good discipline for artists, and especially beginners, to try. Making a straightforward painting of a group of objects that has been set up and lit in a particular way is always a good exercise in handling colour and tone, composition, pictorial space and similar important elements and skills. The lessons learned will obviously be useful when tackling other paintings.

However, still life does not have to be dull! My preference is for 'found' still lifes, but even with a studio arrangement there are various ways of making it more exciting and individual. For instance, the objects themselves can be unusual; can have interesting shapes, colours and textures; can be arranged in an unorthodox way, and so on. Think about how you can use the lighting to create drama, and similarly experiment with the viewpoint and the painting techniques that you use.

Fact and Fiction

Pink Bowl and Summer Fruit
22 x 30.5 cm (8½ x 12 in)
Most of my still lifes are of subjects that I come across in all sorts of places, so I take lots of photographs and use these for reference.

An advantage of still life is that, when working with objects in your studio, you can have total control over the content of the painting and can decide exactly how the various objects are arranged, lit, and so on. However, the majority of my still lifes, such as *Pink Bowl and Summer*

Artist's Materials
46 x 69 cm (18 x 27 in)
*I quite often choose busy subjects such
as this, in which the objects are set
against a very decorative background.*

Fruit (left), are subjects that are 'found' – interesting, ready-made groups of objects that I have noticed somewhere, indoors or out, and that I think will make good paintings. Therefore, to expedite a means of reference and because it would be impracticable to paint on the spot, I use photographs to work from.

Sometimes, before I take any photographs, I make adjustments to the group that I have found. For instance, I may decide to move something to a slightly different position in order to create a better balance or contrast in the composition. Or I may think the design would have more impact if I introduced another object, or perhaps took one away. Unlike the other subject matter that I paint, I find that I need lots of information for still lifes, and so I generally take dozens of photographs – often over a hundred. I try different viewpoints and compositions, take close-ups and more distant shots, experiment with the lighting, and ensure that I have all the necessary reference for specific details, textures and other qualities.

I understand why many artists need to work from the actual objects rather than photographs. But it does depend on your style of painting and the effects you want to create. In fact, especially with still life, I find that using photographs allows me to explore ideas more fully and with more freedom – because their variety prevents me being tied down to a single way of viewing the objects – and in any case I like to be bold and individual in the use of colour and other qualities. So for me there is an advantage in having to use some imagination, and not feeling obliged to portray the objects exactly as I see them in front of me.

Unusual Viewpoints

From the collection of photographs, I may choose one that I consider will give me the most exciting content and layout, or I may decide to combine elements from several photographs, in which case I generally

Sea Treasures I
76 x 56 cm (30 x 22 in)
I like viewpoints in which I am looking directly down on the objects.

Greek White Again (right)
43 x 38 cm (17 x 15 in)
Subjects do not necessarily have to be detailed and complex to make an effective painting. But for every subject there should be something exciting and appealing about it, so that you feel you must paint it.

begin with a quick composition sketch. My preference with still-life paintings is for rich colour and a uniformity of interest throughout the work, as in *Artist's Materials* (page 111). However, sometimes just a simple object against a plain background can make an effective painting, as with *Greek White Again* (right).

Although I have plenty of reference in the photographs, I do not necessarily keep to the colours that are there. A green vase can become a purple one, if purple will work better in the composition. As always, I exaggerate many of the colours, while the principal painting technique is my 'controlled' approach (see page 99), which allows me to build up the painting section by section and gives me time to tackle the different surface effects and details.

I like unusual viewpoints and I am particularly fond of a view from directly above the objects. I also think you can make very interesting designs by including parts of objects as well as entire shapes, as in *Pink Bowl and Summer Fruit* (page 110). For *Sea Treasures I* (above) I did in fact refer to the actual objects. I placed them on a white sheet of paper and painted them in a botanical sort of way, including their cast shadows. Again, this allowed me a lot of control: I was able to work on one object at a time and build up the painting piece by piece.

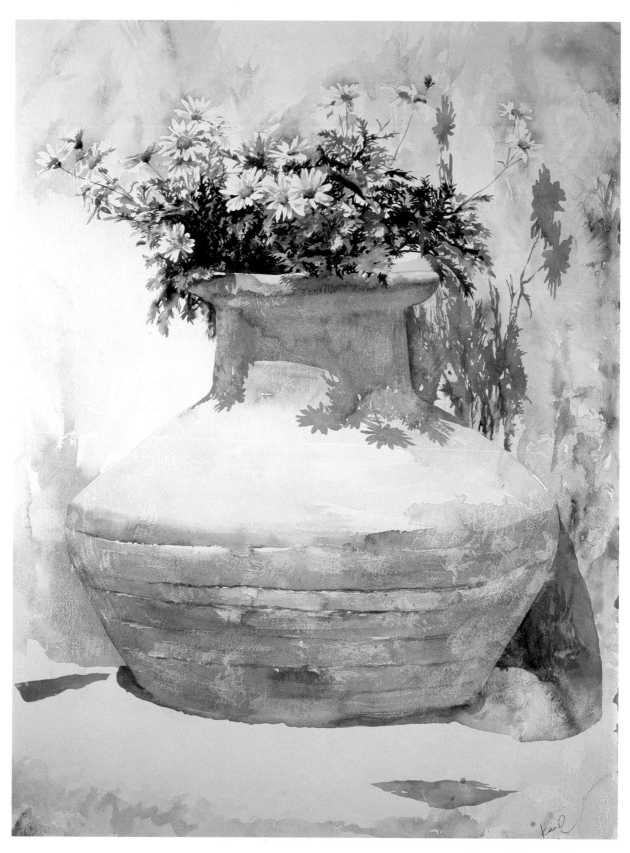

Four Straw Hats
51 x 74 cm (20 x 29 in)
As here, I particularly enjoy
painting garden scenes that
suggest a human presence.

Gardens

Gardens offer immense scope for successful watercolours, whatever your painting style. All the key elements are there (shapes, colours and textures) while the possibilities for interesting compositions include such contrasts as the broad vista and the individual plant or feature. A garden does not have to be elaborate and full of exotic plants to be worthy of a painting. A corner of an allotment can be just as exciting. You could paint in your own garden or that of a friend, or visit large public gardens or country house gardens to find ideas.

The garden subjects that I find most satisfying are those in which there is a narrative, and which therefore engage the viewer more directly in the scene or situation. I especially like garden scenes that include a table and chairs, as these give the painting a particular focus and at the same time imply a human presence. This is illustrated in *Four Straw Hats* (above), in which I hope the chairs look so enticing that the viewer would like to be able to sit down on one of them and enjoy the tranquillity and colour of the surrounding garden.

In other paintings I use parts of a building, doorways and windows, or a discarded wheelbarrow, basket or some other item that suggests there is someone about in the garden. I suppose essentially I am using the garden as a backdrop, but nevertheless the foliage, colour, cast shadows and other elements each contribute in an important way to the overall interest and effectiveness of the painting.

Generally, I like busy subjects – gardens with lots of pots, plants, colours and textures that give me plenty of scope to focus on pattern and colour in the final painting. *Pots on Steps* (above) is a good example of this. Incidentally, in this painting, note the row of pots on the top wall. Rather than having the composition very ordered and controlled, I like the idea of the viewer gradually discovering details such as this. As with the still lifes, I frequently introduce objects, modify the composition, and change or heighten the colour if the garden subject needs more impact.

Shapes and Colours

Garden shrubs and plants are full of different shapes, colours and textures, and therefore can be complex and difficult subjects to paint. Moreover, not all the shapes in a garden are clearly defined. Sometimes one area of foliage is indistinguishable from another. So what is the best approach? As in all painting, there is no set and safe method, of course. Rather, it is a matter of finding your own reaction to the subject and deciding how you want to interpret it. My own view is that there is no halfway house with effects such as foliage. It either has to be greatly simplified or treated in some detail.

For distant foliage I use the spray bottle technique described on page 35. I apply some green paint in a loose, random sort of way, and then lightly spray this with clean water to create a mottled, diffused effect, which in fact is how foliage looks in the distance. In contrast, for close-up foliage I use lots of small separate brushmarks, applied mainly wet-on-dry, to indicate the particular character, colour and texture of the foliage. Where I want the shape of the foliage to suggest the three-dimensional form of a plant, shrub or tree, as in *Four Straw Hats* (page 114) for example, I take note of the lights and darks and make full use of the shadows and highlights.

Flowers

This is another subject that is ideal for an individual response with an emphasis on colour. Again, there is plenty of potential for successful work, whether your interest is in making very accurate studies of flowers

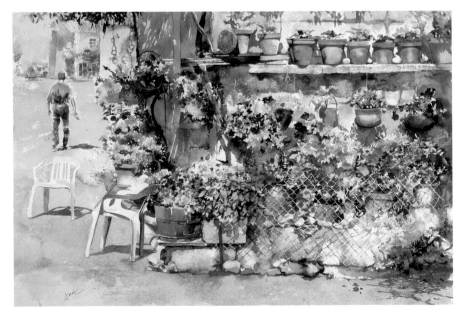

Short Walk
51 x 74 cm (20 x 29 in)
I like the sort of flower subjects that you come across in the street, particularly in the Mediterranean. Note the use of masking fluid for the wire mesh.

– perhaps in the manner of a botanical illustrator – or whether you prefer to paint in a more expressive way and tackle colourful floral borders, flowers in pots on a patio, or similar general views. Although I am not a keen gardener myself I enjoy looking round gardens, both in the United Kingdom and in Europe, and it is mostly on these visits that I find exciting flower subjects to paint.

Flowers in pots and hanging baskets are subjects that I particularly enjoy painting. I am always impressed by the seemingly casual yet nevertheless artistic arrangements of pots and hanging baskets that are found in many of the narrow streets and tiny courtyards of Mediterranean countries. In Greece especially, people use a surprising variety of containers, including buckets and old olive oil cans, in which to grow their colourful array of flowers, making every terrace and courtyard a delight to see. *Short Walk* (left) was inspired in this way.

If you have not painted flowers before, my advice is to start with some drawings and watercolour sketches. While the science of flowers, their structure and other botanical qualities, need not unduly concern the

Begonias and Hose
51 x 71 cm (20 x 28 in)
Flowers in pots are one of my favourite subjects.

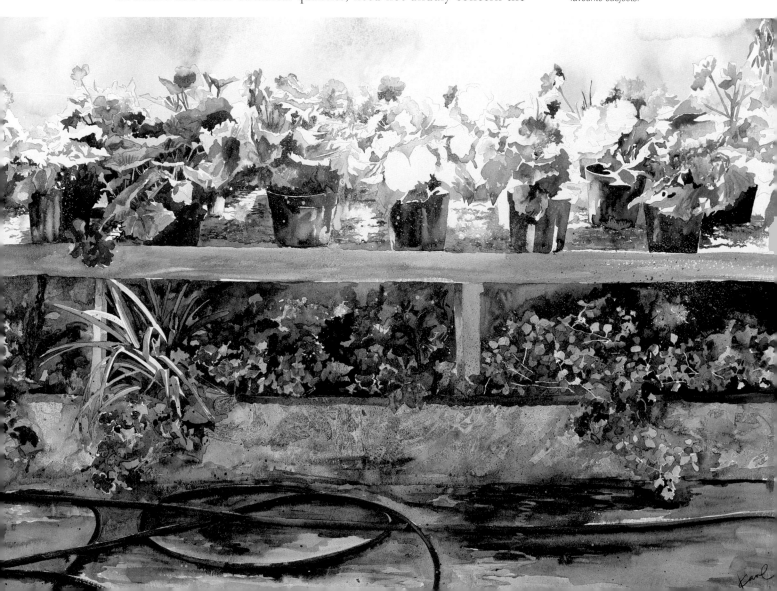

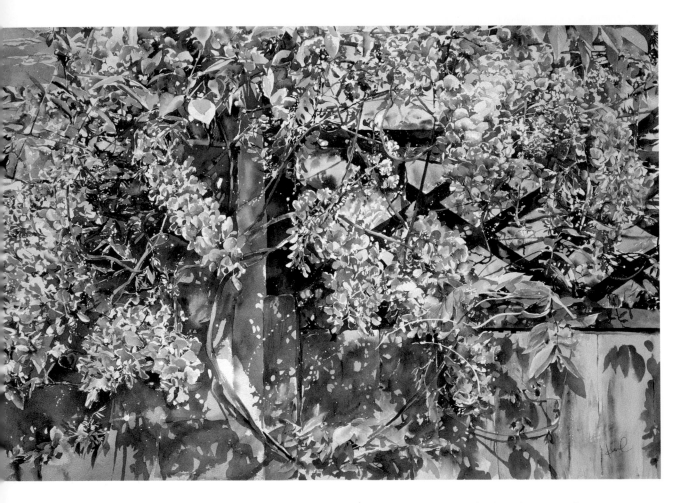

Wisteria at Two Ten
61 x 94 cm (24 x 37 in)
I think the inclusion of the fence and trellis adds some contrast and aids the composition in this flower painting.

artist, there is obvious value in having studied and acquired some knowledge of different leaf and petal shapes, proportions and other essential characteristics. Later, using that experience, it should be possible to work more freely and, as I do, without the actual flowers in front of you. With flowers, as with the majority of other subjects, I rely on good quality photographs for reference, and again, because the emphasis is on pattern and colour, I will change or exaggerate the colour as necessary.

Flowers in a Context

Generally I like a composition in which the flowers are seen in some kind of setting. I think this makes a far more interesting painting and creates greater impact than concentrating solely on the flowers. Invariably the setting helps suggest something more about the flowers. They have a context, even if it is just a small area of wall or fence as a background, which is the effect I have used in *Wisteria at Two Ten* (above). In contrast, for the large watercolour *Spring Pots* (right) the setting is a conservatory, and in both these examples the cast

shadows across the background add further interest and help create a sense of depth.

In order to make visual sense of a flower subject such as *Wisteria at Two Ten*, which is a very complex arrangement of petals, leaves, shadows and other shapes, I look for strong tonal contrasts as well as an all-over pattern and colour effect. As I mentioned with regard to foliage on page 116, it is the lights and darks that give meaning to the subject by suggesting three-dimensional form. Basically, areas that are well lit are seen very clearly and therefore painted in detail, whereas those in shadow are less distinct and so perhaps painted wet-into-wet to produce a blurred effect like that in the actual subject matter.

I start each flower painting by lightly drawing on the watercolour paper in pencil to give me the main shapes I need. Interestingly, I normally do less drawing for a flower painting than for other subjects – I add all the detail directly in paint. The faint pencil lines act as a guide rather than positively defining the shapes, and once they are made I try not to alter them. It is important to draw faintly because use of an eraser should be avoided; on watercolour paper, even a good-quality kneadable

Spring Pots
61 x 99 cm (24 x 39 in)
Generally I look for a composition that shows the flowers in some kind of setting, in this case a conservatory.

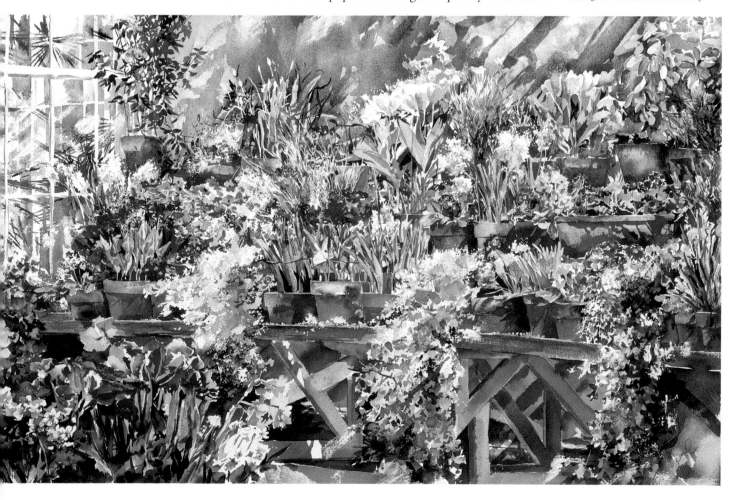

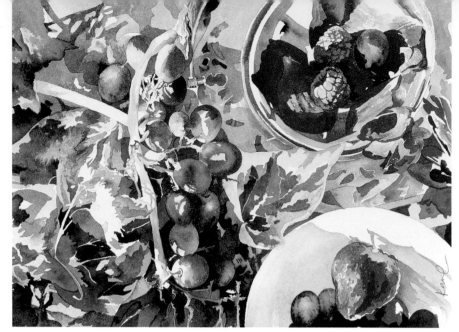

Fruit
28 x 38 cm (11 x 15 in)
Fruits and foliage also make interesting subjects.

putty eraser can badly damage the surface and so affect the way the paint responds. Eventually all the pencil marks are painted over, and because I use quite thick colours, the lines disappear into the painting.

Water

Frog
69 x 74 cm (27 x 29 in)
Shadows falling on the water surface are especially fascinating things to paint. Note also how we can see the green of the leaves above reflected in the water.

Water adds a distinctive character and mood to a painting and creates an interesting context for subjects such as boats and buildings, which for me are normally the principal focus of attention. One of the reasons I like painting water is that it is always different. Depending on the shapes, colours, movement and other factors on its surface and around its edges, water assumes many guises, and consequently demands a fresh painting technique every time. I like the fact that sometimes just a

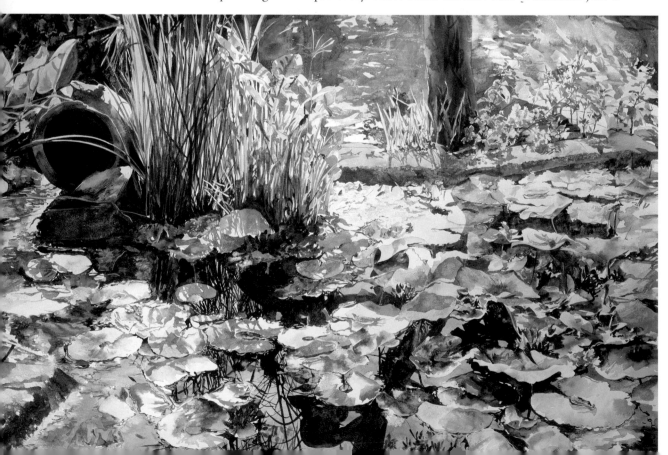

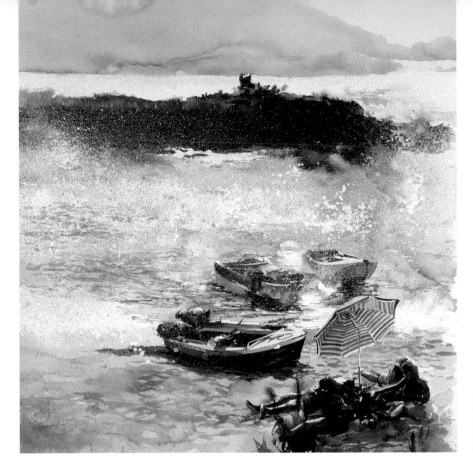

Weighting the Pale Sky
41 x 41 cm (16 x 16 in)
Here the attraction was to capture the effect of the light on the sea and the splashing waves.

couple of broad strokes will convey the impression of water, while on other occasions a far more detailed approach is required to give a convincing sense of depth, reflections and similar qualities.

Most artists consider water a difficult subject to paint. This is not surprising because there are so many things to be aware of – the reflections and other shapes that you can see in the water, the light on the surface, the movement of the water, the various colours, and so on – and all these effects have to be dealt with at once and preferably with a single application of paint. Generally it is not possible to have a second go at it, because by adding more colour you are likely to destroy the essential qualities of transparency and translucency that you are trying to create.

As usual, observation is the first step to understanding and interpreting water. The best approach, I think, is to consider water in the same way that you would any other surface or shape. Forget that it is a complicated subject and instead concentrate on the qualities that define its nature and appearance. What impresses you most about the water, and which techniques will work best and give you the effects you want to express? Personally I would always emphasize those effects, to really bring home the points that I feel are important. As I have stressed before, in order to create the desired impact in a painting you have to exaggerate those elements that most contribute to the aims and effects you have in mind.

Mood and Movement

In theory, water is transparent and does not have any distinct colour of its own. So the colours that we see in the water are all reflected from

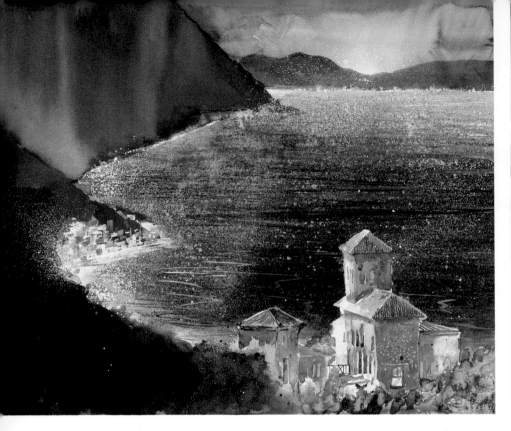

Italy, Greece, Spain
56 x 66 cm (22 x 26 in)
Again here, it was the glinting light on the water that I wanted to capture, as well as the dramatic mood of the scene.

Levos Coast (far right)
76 x 51 cm (30 x 20 in)
Generally a wet-into-wet technique is the quickest way to achieve a convincing effect when painting water.

elsewhere. Therefore, when painting water, the most important things to study are the reflections. They tell us everything about the colour, mood, movement, depth and other qualities associated with the water. If the reflections are broken or blurred, then the water is disturbed or flowing at speed, and if they are clearly defined, then the water is calm.

Once an assessment has been made about which colours will be required to paint the reflected colours and shapes in the water, then these should be mixed and made ready, for it is usually necessary to work quickly. The main technique for painting water is wet-into-wet or wet-against-wet (see page 26 for a description of these techniques). It is still possible to work with some control, as long as you do not allow any unfinished edges to dry.

The main point to remember is that reflected shapes are an integral part of the water surface and volume, and not something to add or consider later. There sometimes are ways of salvaging areas that have not worked out quite as expected, although in my experience rewetting areas and trying to sponge off or lift out colour is not the best approach. I prefer to add rather than attempt to remove paint, and for this I use opaque colours such as spattered white ink or white gouache, which are particularly effective for the glints and highlights on water.

Buildings

My interest in painting buildings began some years ago after a trip to the Greek Islands. On Thira and other islands in this region there are many small hillside villages, including several that I thought were extremely impressive in the way the buildings seemed to cling to the mountainside and almost topple into the sea. I thought the play of those shapes, set

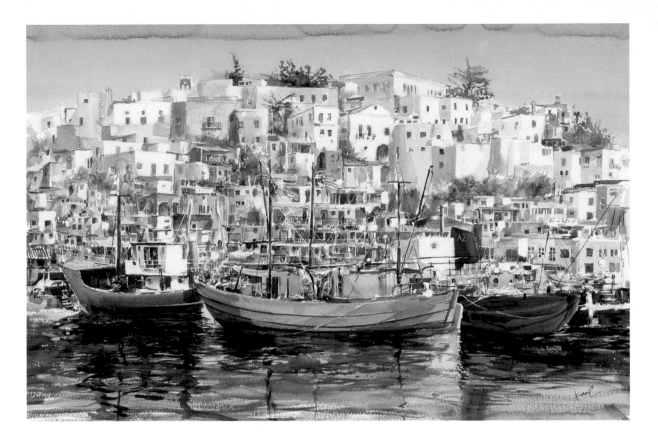

against a blue sky, offered tremendous possibilities for paintings, and subjects of this type have remained a favourite theme of mine ever since. With buildings, it is essentially the shapes that attract me, especially the domes and 'sugar cube' shapes that are found in certain parts of the Mediterranean.

A mass of shapes, like those in *Dock* (above), creates a sort of pattern effect and breaks up the composition in the perfect way for working with a controlled watercolour technique. This suits the way I like to paint, and I also like the fact that areas can be treated in an almost abstract fashion, contrasting with other parts that are dealt with in a more detailed and realistic style.

With the hillside village subjects I can be very inventive. Because the basic shapes are mostly square and rectangular, I can add or take away shapes as I wish, in order to create an effective composition. In fact, it is possible to completely reconstruct the village and its colours, and still have a convincing painting. For me, a painting does not necessarily have to represent a particular place.

Creative Design

The principle of visualizing buildings as a series of basic shapes is, of course, something that can be applied to all types of buildings, not just those around the Mediterranean. This is a good way to plan a composition and, as I have said, shapes can be adjusted and colours altered if this adds more impact to the painting. I prefer viewpoints that present the buildings face-on to me, because this gives the sort of pattern of shapes and colours that I like to use. Often my composition does not show the horizon, and therefore a key reference to space and

Dock
76 x 119 cm (30 x 47 in)
For this very large watercolour, what I especially liked about the subject matter was the contrasting shapes of the boats and the buildings.

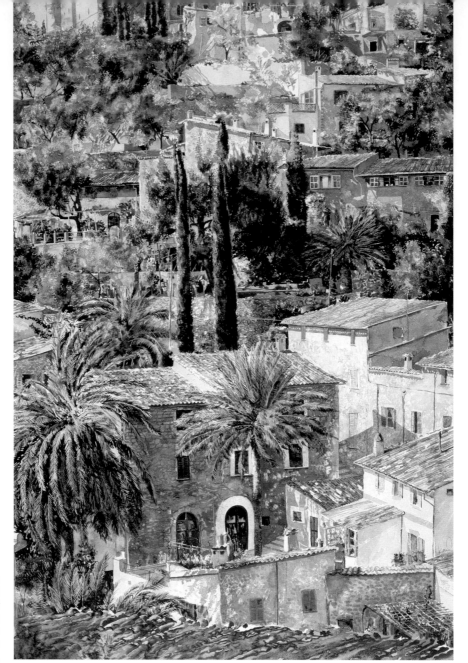

Deia
69 x 44.5 cm (27 x 17½ in)
I like buildings on hillsides because it is easier to compose the painting without an horizon. This removes the sense of depth and emphasizes the pattern qualities.

depth is removed and I can concentrate on the interaction of shapes and colours.

In other paintings I use a more conventional viewpoint, which means that the buildings may be set at different angles, as in *Deia* (above). But where this is so I do not worry too much about the theory of perspective and such matters as vanishing points, eye level and centre of vision. Instead, I judge the relative position of the buildings, the slope of the roofs, the angle of each roofline and so on by observation, and by comparing one line or shape with another.

Another consideration with buildings is judging how much detail to include. Too much detail can be overpowering and actually detract from other more important elements in the painting. Generally, contrast foreground detail with distant simplicity. Remember too, as in all subject matter, that shadows, highlights and other lighting effects can play a vital role in helping to suggest form and depth.

Night Gathering
53 x 71 cm (21 x 28 in)
Buildings at night are subjects that offer scope for dramatic lighting effects.

Doorways and Windows

In the same way that a wheelbarrow in a garden implies a human presence, so does a half-open door or window, or a balcony with chairs and colourful pot plants. This is one of the reasons why I like painting views that perhaps are based on just a single window or doorway. They create the setting for a narrative, which the viewer's imagination can subsequently complete.

I am also attracted by the simplicity of this type of subject matter – the fact that you can devise a composition with just a few squares or rectangular shapes. Similarly, I like the formality of working with horizontals and verticals, because this allows me to shift the emphasis in interpretation from a concern for depth and space to an approach that places equal importance across the picture surface. Usually I take a very close-up view

She Went Inside and Shut the Door
56 x 76 cm (22 x 30 in)
With doorways and windows I often look for a viewpoint that is flat-on to the subject and that consequently creates interesting symmetrical compositions, although in this case the building is set more into the surroundings.

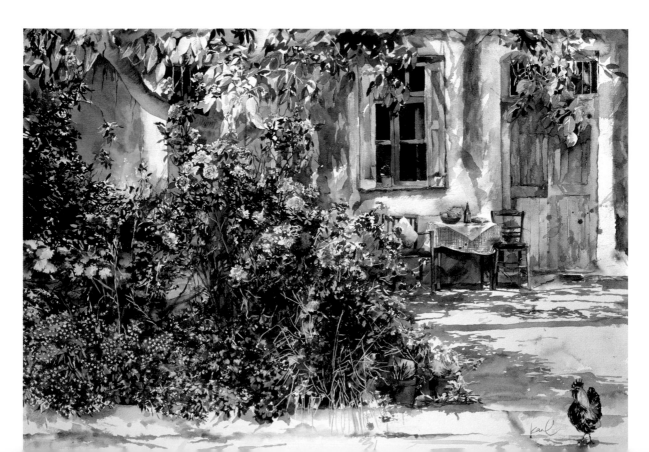

of part of a façade, and the only reference to depth will be through the use of shadows or the fact that a window or door is partly open.

The type of composition shown in *She Went Inside and Shut the Door* (page 125) allows me to adopt a very controlled approach, as explained on page 99. With this method, because I am mostly working with individual brushstrokes rather than large washes of colour, there is time to introduce and develop whichever techniques are appropriate for the different surface textures and light effects. Even with a more complex idea, as in *Spanish Balconies* (right), I am able to work with a similar degree of control due to the way that the shapes conveniently divide up the picture surface.

Flowers in Pujols
53 x 74 cm (21 x 29 in)
I like the simplicity of this type of subject matter and the way that you can compose with basic shapes.

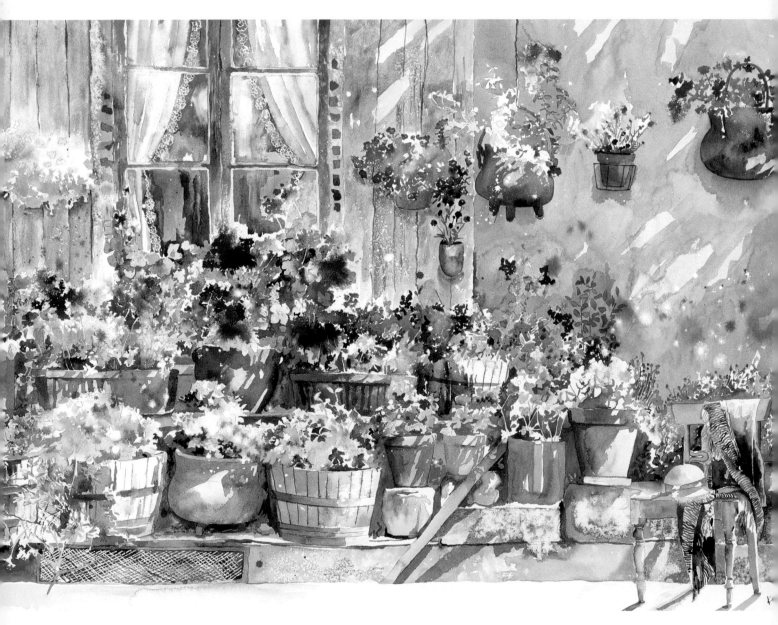

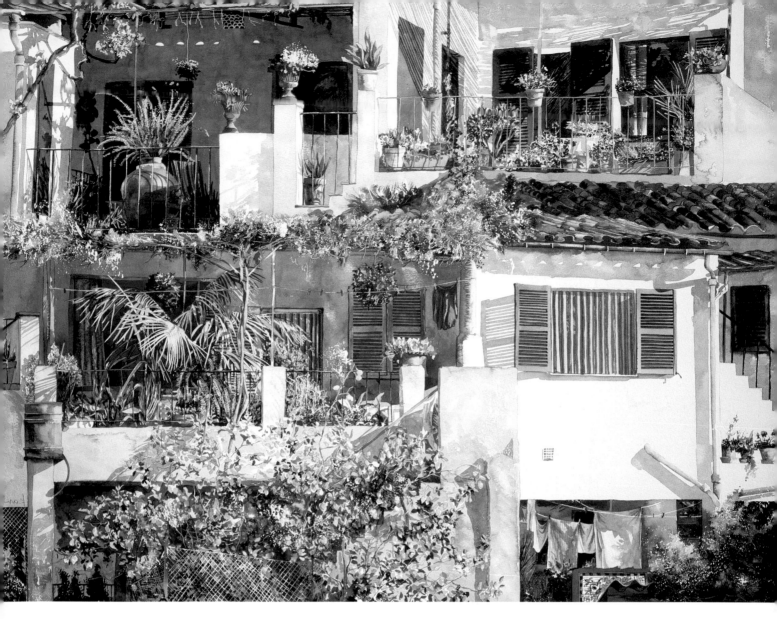

Being Bold!

Doors and windows are good subjects to try if you do not feel very confident about composition, and indeed they have advantages that will help you improve other aspects of watercolour painting. Essentially, as in any painting, you are working with shapes and colours, but here you can make the design and painting process as simple or as complex as you wish. Having started with a few basic shapes and colours, you could gradually begin to experiment with shadows, textures, greater detail and different painting methods.

Whatever your level of ability, the message that I hope comes through in this book is that watercolour can be used boldly and with plenty of feeling and expression. There is no one method of painting in watercolour. Of course it is necessary to acquire experience and confidence, and equally to develop an understanding of the medium and to respect its particular qualities. But those points accepted, you should seek your own way of working with watercolour and not be afraid to see where it will lead you. The results can be truly exciting and rewarding!

Spanish Balconies
56 x 76 cm (22 x 30 in)
Although this appears to be a complex subject, in fact it can be divided up and painted as a sequence of separate but related areas.

Index